IMAGES
of America

CHICAGO'S CLASSICAL ARCHITECTURE
THE LEGACY OF THE WHITE CITY

To Dan —
Hope you enjoy
this book on
Chicago's history —

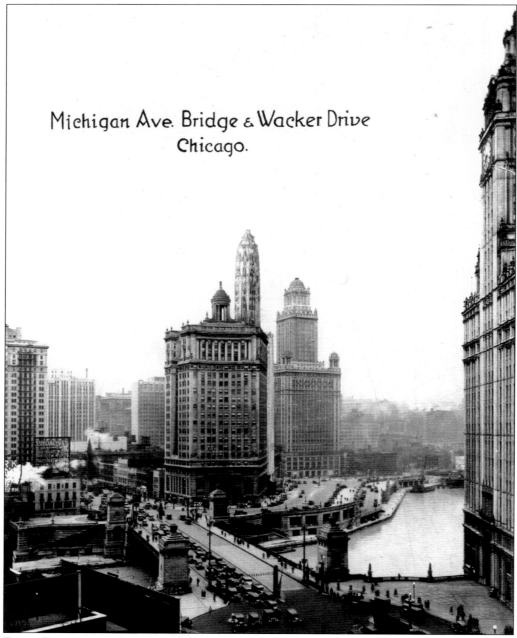

Michigan Ave. Bridge & Wacker Drive
Chicago.

EARLY DOWNTOWN DEVELOPMENT. To the south of the Michigan Avenue Bridge, which was completed in 1920, is the London Guarantee and Accident Building, at the intersection of Michigan Avenue and Wacker Drive. The Jeweler's Building is to the right, past the slender Mather Tower. Both the London Guarantee and Jeweler's buildings, as well as the bridge and the adjacent Wacker Drive Esplanade, are Chicago landmarks and are also significant examples of early-20th-century classical building that resulted from the 1893 Columbian Exposition and its "White City." In the foreground on the right is the Wrigley Building, another classical masterpiece. (Courtesy Patricia Parisi.)

IMAGES
of America
CHICAGO'S CLASSICAL ARCHITECTURE
THE LEGACY OF THE WHITE CITY

David Stone
with an introduction by Carroll William Westfall

ARCADIA

Published by Arcadia Publishing
Charleston SC, Chicago IL, Portsmouth NH, San Francisco CA

Printed in the United States of America

Library of Congress Catalog Card Number: 2005925971

For all general information contact Arcadia Publishing at:
Telephone 843-853-2070
Fax 843-853-0044
E-mail sales@arcadiapublishing.com
For customer service and orders:
Toll-Free 1-888-313-2665

Visit us on the Internet at http://www.arcadiapublishing.com

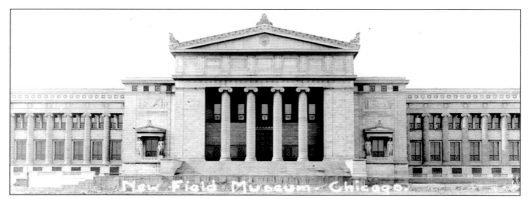

FIELD MUSEUM OF NATURAL HISTORY. This photograph shows an early view of the Field Museum, which, along with the adjoining Grant Park, was one of the main elements of Daniel Burnham's post–Columbian Exposition urban planning in Chicago. He anticipated developing Grant Park as the city's intellectual center, while making the adjacent lakefront as beautiful and accessible as possible.

CONTENTS

ACKNOWLEDGMENTS

This book is by no means an exhaustive collection of Chicago's classical architecture, but I have tried to depict a representative sample—by building type, geography, style, and era—based on the best available images. (Buildings are sometimes labeled by their historical names and other times by their current names, depending on how they are most commonly known.) Classical elements often appear within many other architectural styles, which fortunately helps to provide such great variety; however, the buildings and monuments shown here are either predominantly classical or have noteworthy classical components, such as a colonnade on a Renaissance or Gothic church. With a few notable exceptions, all images shown in this book are exteriors that are or were visible to anyone casually walking, riding, or driving through Chicago in the last 130 years or so.

This book would not have been possible without the assistance of numerous people and groups. First, I would like to thank everyone whose previous research on this subject I have so often relied on; unfortunately, there are too many to name here, but Hubert Howe Bancroft's *The Book of the Fair*, the City of Chicago's Historic Resources Survey, and *The AIA Guide to Chicago* particularly stand out. I would also like to thank everyone who allowed me to use their images and assisted in providing archived photographs, particularly Kristin Standaert at the Illinois Institute of Technology's Paul V. Galvin Library, Teresa Yoder and the staff at Harold Washington Library's Special Collections and Preservation Division, Patricia Bakunas at the University of Illinois at Chicago's University Library (Special Collections), Julie Lynch at the Chicago Public Library's Sulzer Regional branch, and Bruce Moffat and Joyce Shaw at the CTA. Finally, thanks to Samantha Gleisten and especially Melissa Basilone at Arcadia for being on my side, and a very special thanks to Bill Westfall for his incredible generosity with his time and wisdom, and for helping to make me not look stupid.

INTRODUCTION

Louis Sullivan, Frank Lloyd Wright, and others in their circle have justifiably made Chicago a mecca for those who love architecture. Had they never lived, Chicago would still be a mecca for those who love architecture. They would revel in a city displaying a vast range of buildings—institutional, residential, commercial, and industrial—attesting to the continued vitality of the classical tradition. Chicago's classical buildings are generally of a higher quality than those in other cities. They occupy a greater proportion of all that was built. Many of the best among them have survived. And they play a more dominant role in the sense of the urban character of the city than in most other American cities.

We owe this to the 1893 Columbian Exposition. Built by Chicagoans, residents of a smoke-begrimed black city with streets befouled by all manner of garbage, offal, and detritus, their White City in Jackson Park inspired Americans to transform their cities in its image.

The fair was built to gain America recognition as a leading nation in the world. Its builders competed with others in a contest stretching back 2,500 years or more. The buildings and cities that states built were impressive in the same ways as their predecessors' cities, but at the same time, they were distinctly different. The similarities allowed for comparisons; the differences allowed for competition. The result is an unbroken classical tradition initiated by the Greeks, transformed by the Romans, altered almost beyond recognition in the transcendental constructions of Gothic churchmen, and then, after 1400 in Italy, a vigorous restoration of ancient rules and practices that were drastically revised and updated produced new kinds of churches, palaces, and other buildings that were used in ways utterly unknown in antiquity.

The new United States, a fledgling among nations, entered this competition with vigor. Embracing classical architecture for its most important institutional buildings allowed people to recognize the ancient sources for many of its governmental institutions. That decision allowed Americans to show that they knew how to build well and impressively according to standards of beauty and civil decorum that had more than two millennia of authority behind them. But like their predecessors across the centuries, Americans demonstrated their nation's special character by building in ways that uniquely suited them. They proved that the government and the private individuals who built these buildings were ready to take their place on the great world stage and to do great things.

Explosive growth in population, industry, and commerce swept the world during the 19th century. By 1893, Chicago, not yet 60 years old, was one of the world's most industrious, prosperous, and populous cities. Like others everywhere, its architects and builders, who possessed more energy than education, reveled in the potential of new materials and invented new building types to serve new needs. Classicism, with its religious ally the Gothic, remained the reigning manner of designing, but the buildings displayed more drama and fashion than knowledge of the classical traditions leading to beauty in the individual building and the urban ensemble. Their fruits are still abundantly visible in Chicago. The city's oldest building,

the Clarke House, embodies the chaste simplicity of the early republic. Typical buildings from just before the fair, for example, the Cyrus McCormick Mansion or the Germania Club, show more independent exuberance than respect for tradition in how they use classical elements.

The fair changed all that. Here people learned the benefit of disciplining architecture with tried-and-true classical proportions, harmonies, compositional patterns, and sense of coherence and enriching it with the great variety available within the many different traditions that had used the repertoire of classical forms, each in its own way: columns, pilasters, entablatures, arches, plinths, intermediate moldings, cornices, window surrounds, and so on. Whether in modern Chicago or ancient Rome, a good classical building will always look both familiar and innovative. It will look as if it would be at home in any city that took itself seriously as a place for leading the good and civil life, and it would also look as if it belonged only in the city in which it was built. It will be both distinctive as an independent entity and a decorous part of a larger, urban ensemble. The best classical architecture has always united these extremes. The fair presented a bewitching if evanescent vision of that capacity, and in so doing, Daniel Hudson Burnham and his many talented colleagues forever transformed American architecture and city building.

The fair led Chicagoans to transform the black host city into the city beautiful, a task the Depression cut short. A generation of architects, many of them trained at the Beaux-Arts school in Paris or in offices where the lessons of the Beaux-Arts were available, participated. They produced a tremendous variety of classical buildings, some exhibiting the latest fashions, others sticking close to ancient Greek standards, some experimenting with daring new technologies, others giving new interpretations of the most conservative building techniques, some meant for fun, others for the most serious activities of civil life, and so on. The result is a city people could love, but one that was nearly fatally assaulted by the Depression, by new demands for efficient transportation, by unthinking disregard for poor people and poorly maintained buildings, and by the current insatiable quest for novelty.

But the classical legacy of the fair was too powerful and pervasive to succumb. Every day it acquires new fans because it reveals a Chicago that is a beautiful and decorous setting for living a civil life, a city based on the vision that has always permeated classical architecture, the vision that was so forcefully presented to America at the fair and continues to invigorate Chicago. This wonderful collection of photographs and commentary, the product of David Stone's energy and love, presents a mere sliver of the full classical Mecca-Chicago. It will lead to vistas you can then discover on your own. Enjoy!

<div align="right">

Carroll William Westfall
Frank Montana Professor of Architecture
University of Notre Dame
May 20, 2005

</div>

One

THE 1893 WORLD'S COLUMBIAN EXPOSITION

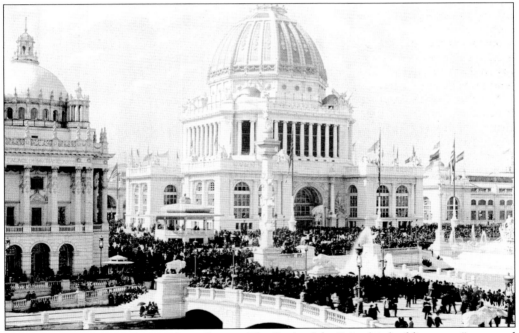

ADMINISTRATION BUILDING. According to *The Book of the Fair*, this building was "esteemed as the architectural gem of the Exposition," with the possible exception of the Palace of Fine Arts. In this image, attendees cross a bridge to the Grand Plaza on Chicago Day (October 9, 1893). The building was generally in the French Renaissance style, with four Doric corner pavilions and second-level Ionic colonnades, and its 275-foot dome was the highest point in the White City. Its designer, Richard M. Hunt of New York, was appropriately the leading architect of the time. He was the cofounder and president of the American Institute of Architects, studied at the Ecole des Beaux-Arts (which directly inspired the fair's design), and worked on the design of the dome of the Capitol in Washington, D.C. (Courtesy Paul V. Galvin Library, Illinois Institute of Technology.)

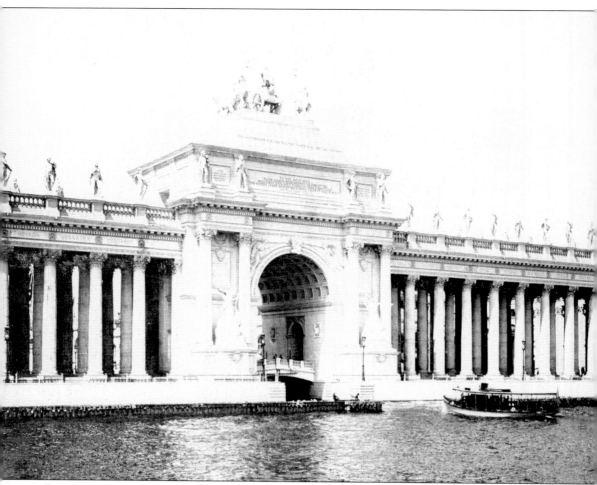

PERISTYLE AND COLUMBUS ARCH. In this view looking west from Lake Michigan, fairgoers enter the White City on gondola through the Columbus Arch, "the poetic gateway to the dreamland of the Fair." The structure featured a series of 48 Corinthian columns, each representing a U.S. state or territory, with an inscription of each area's name, coat-of-arms, and representative statue on top. At the center of the Peristyle was the magnificent arch, which was dedicated to Christopher Columbus and inscribed with the names of history's great explorers. The harbor, with the arch at its center, was adjacent to a pier with a 2,400-foot movable sidewalk that also brought attendees into the fairgrounds after arriving on boat from downtown Chicago. (Courtesy Paul V. Galvin Library, Illinois Institute of Technology.)

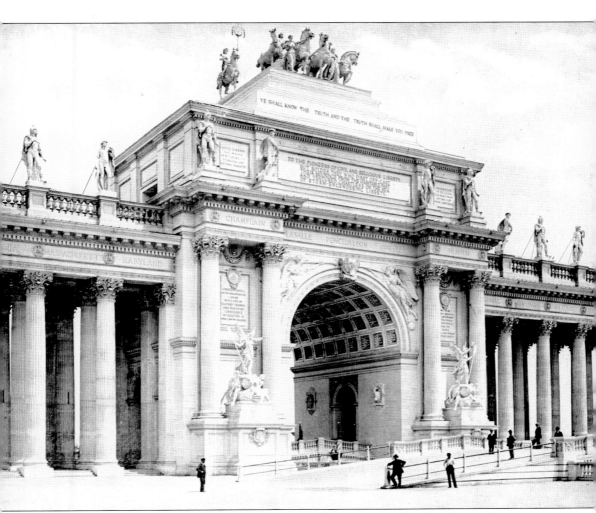

PERISTYLE AND ARCH FROM THE FAIRGROUNDS. The western side of the Peristyle and arch featured other inscriptions, including "Toleration of Religion the Best Fruit of the Last Four Centuries" and "Civil Liberty the Means of Building Up Personal and National Character," both of which epitomized the fair's values and emphasis on creating a better society. Atop the arch is the Columbus Quadriga (or four-horse chariot), which depicts the famous explorer. Connected to both ends of the Peristyle were twin pavilions, the 2,500-seat Music Hall and the Casino, which served as a waiting hall for boat passengers. In each corner, between the pavilions and Peristyle, was a replica of the Roman Forum's Temple of Vesta. (Courtesy Paul V. Galvin Library, Illinois Institute of Technology.)

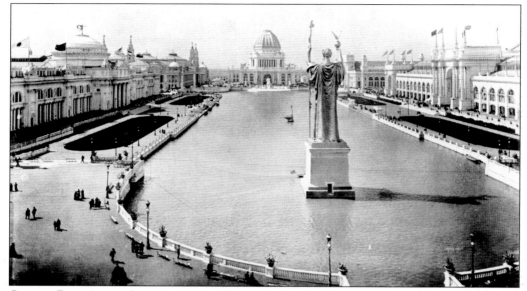

GRAND BASIN AND COURT OF HONOR. This view, looking west from above the Peristyle, shows the back of the Statue of the Republic, flanked by Great Buildings on the sides of the Grand Basin, and the Administration Building at the opposite end. The 65-foot-high statue, by Daniel Chester French, represented liberty, and its beauty "would satisfy the sculpture of the old Greek school," according to one fair guidebook. The basin was 350 feet wide and 1,110 feet long. (Courtesy Paul V. Galvin Library, Illinois Institute of Technology.)

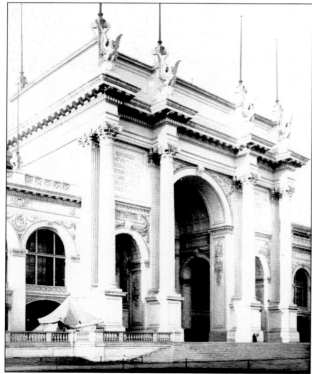

MANUFACTURES PORTAL. The huge Manufactures and Liberal Arts Building had a grand central portal on each of its four sides. Designed after Roman and Parisian triumphal arches, the portals were so large that the 18-foot eagles placed above the Corinthian columns seemed life-sized in comparison to their surrounding decoration, such as the columns that soared above the 60-foot-high lower cornice. (Courtesy Paul V. Galvin Library, Illinois Institute of Technology.)

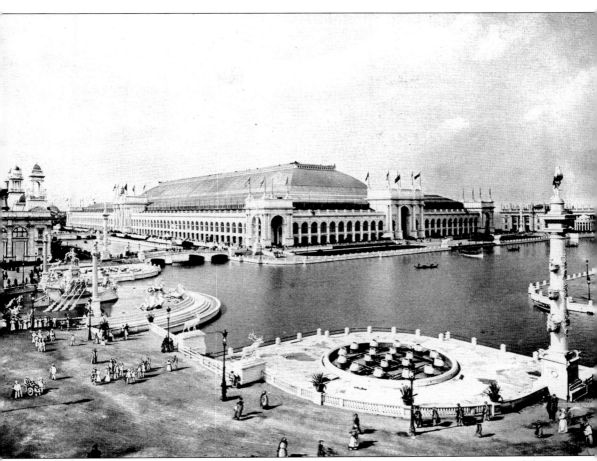

MANUFACTURES AND LIBERAL ARTS BUILDING. This building was not only the largest of the Great Buildings but, at 1.3 million square feet and with a floor space of 30 acres, was billed as the largest building in the world. It fronted the Grand Basin, as did the Agricultural Building across from it, but extended for nearly one-third of a mile to the north along Lake Michigan. *The Book of the Fair* had this to say about the building: "Not only for its size, but for its severely classical style, its grandeur of motif, and its unity of composition, its peristyle of fluted columns, nearly a mile in length, but relieved by hundreds of symbolical figures, its four great portals one in the middle of each façade, fashioned like triumphal arches, its corner pavilions, with their spacious entrance ways, of themselves temples of art—for these and other features the hall of Manufactures and Liberal Arts is one of the most marvelous among all the marvels of modern architecture." (Courtesy Paul V. Galvin Library, Illinois Institute of Technology.)

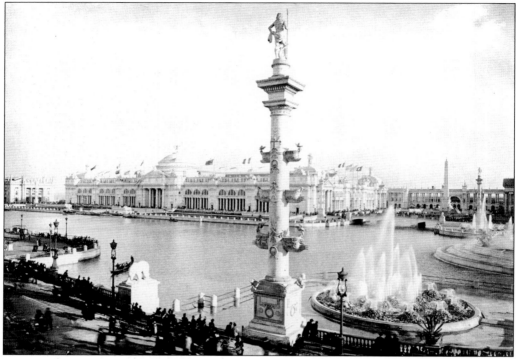

Agricultural Building. The building's central dome, 130 feet in diameter, was topped by Augustus Saint-Gaudens's Statue of Diana, which was originally designed for Madison Square Garden in New York but was too big for the arena. New York–based McKim, Mead and White designed the building. *The Book of the Fair* called the building "among the most sightly of the Exposition palaces [with] its chaste and serious design, its wealth of decorations, and richness and variety of detail." (Courtesy Paul V. Galvin Library, Illinois Institute of Technology.)

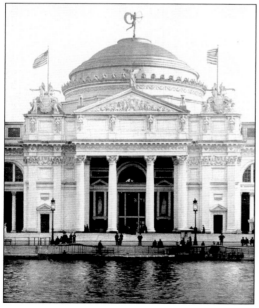

North Entrance of the Agricultural Building. Facing Manufactures and Liberal Arts, the stairway of the porch shown here leads directly into the Grand Basin. Around and above the porch are figures from Greek mythology that relate to agriculture, including Ceres, Cybele, and King Triptolemus, and Saint-Gaudens's Diana is visible at the crown of the building's dome. (Courtesy Paul V. Galvin Library, Illinois Institute of Technology.)

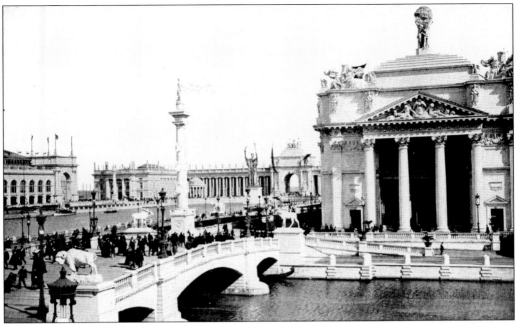

THE FARMER'S BRIDGE. This bridge crossed the southern canal of the Grand Basin between Machinery Hall and Agriculture. To the right is the northwest porch of Agriculture, with the Peristyle and Statue of the Republic in the background. Toward the center of the image is one of the Grand Basin's Rostral columns, which is a Roman creation that commemorates naval victories. (Courtesy Paul V. Galvin Library, Illinois Institute of Technology.)

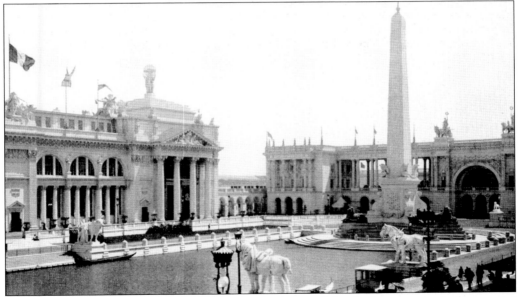

OBELISK. In the water-based layout of the fair (to honor Columbus's sea voyage), the termini of the Grand Basin, canals, and lagoon were accented by high-profile structures, such as this obelisk. An obelisk was originally an ancient Egyptian form but is often adopted into classical architecture. (Courtesy Paul V. Galvin Library, Illinois Institute of Technology.)

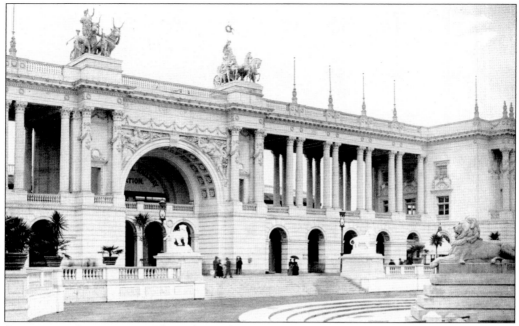

SOUTHERN COLONNADE. The colonnade was at the southern edge of the fairgrounds and acted as a screen to block attendees' views of car yards, stock pavilions, and other utilitarian buildings. The Corinthian colonnade stretched from Agriculture to Machinery, behind the obelisk and the south canal and, like the much larger Peristyle to the east, was centered on a triumphal arch topped by symbolic statues. (Courtesy Paul V. Galvin Library, Illinois Institute of Technology.)

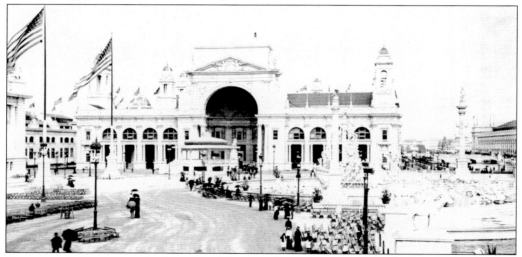

ELECTRICITY BUILDING. At the time of the fair, electricity was still a relatively new concept— or the "youngest and most progressive of modern sciences" and one that was "surpassing the wonders of dreamland," according to *The Book of the Fair*. The building was appropriately illuminated at night, which drew huge crowds, and architect Henry Van Brunt designed the French Renaissance chateau building to be more "joyful" than others in the Court of Honor. (Courtesy Paul V. Galvin Library, Illinois Institute of Technology.)

ELECTRICITY BUILDING PORTAL.
This entrance to the Electricity
Building appropriately faced the
Grand Basin, and it was written
that "it is quite likely that there
was nowhere else on the grounds a
portal so grand and beautiful." Two
levels of Corinthian columns and
pilasters and an arch were topped
by a decorative pediment with
figures that represented electricity.
The statue in the center of the
vault depicts Benjamin Franklin
with his kite. (Courtesy Paul V.
Galvin Library, Illinois Institute
of Technology.)

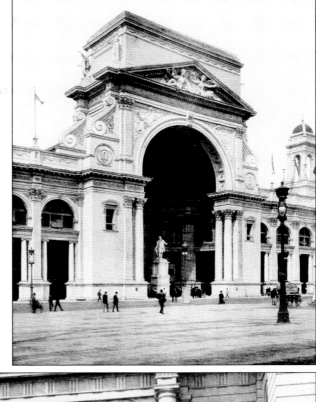

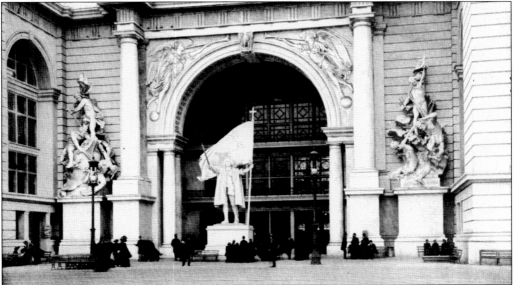

EAST PORTAL OF ADMINISTRATION. Facing the Grand Basin, at one of the fair's central
meeting spots—"here the music was rarely silent, here the fountains unfurled their waters,"
according to *The Dream City*—was this statue of Columbus landing in the New World. The
statues to the left and right were called *Water, Controlled* and *Water, Uncontrolled*. *Controlled*
depicted man's mastery over the seas, and *Uncontrolled* showed Neptune destroying his victims.
(Courtesy Paul V. Galvin Library, Illinois Institute of Technology.)

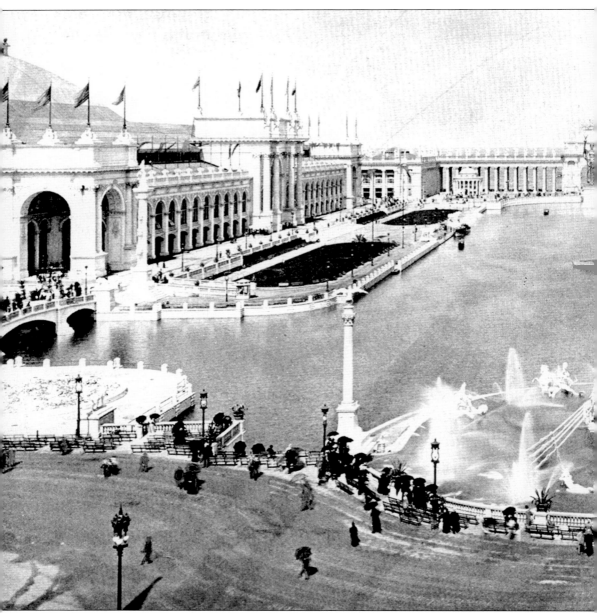

GRAND BASIN AND COURT OF HONOR. From the Administration Building, looking east, the Peristyle is visible at the far end of the Grand Basin. To the right of the basin is the Agricultural Building, and the Manufactures and Liberal Arts Building is on the left. At the western (near) edge of the basin is the Columbian Fountain, which became better known as the MacMonnies Fountain after its designer, and featured a female Columbia in a boat with Fame and Time, with symbols of the arts, sciences, and industry rowing the boat. In the White City, architects had to conform to a number of guidelines set by director of construction Daniel Burnham, including a 60-foot cornice height, the use of classical architecture, and a dominant building color of white (although many of the buildings did feature various colors). The resulting harmony and order of the buildings was known as the Beaux-Arts style, named after the Ecole des Beaux-Arts (School

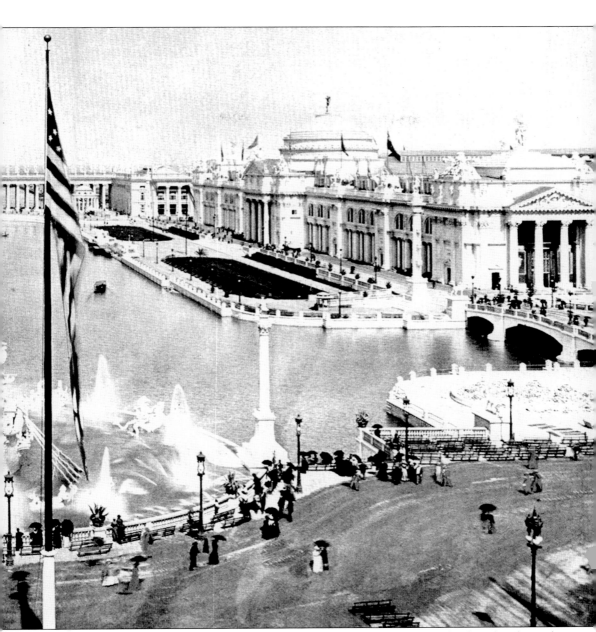

of Fine Arts) in Paris, which trained many of the fair's architects and taught that the classical Greek and Roman styles were the height of architecture and design. Beaux-Arts architecture is also known for its grand scale and its more decorative and eclectic interpretation of classical architecture (often inspired by the Renaissance). The White City had a significant impact on American architecture and urban planning after the fair ended. It led to the City Beautiful movement, which attempted to improve city life, social problems, and other early-20th-century urban ills through the use of well-planned, inviting, clean, orderly, and magnificent public buildings and spaces. As the first example of such an arrangement, the Beaux-Arts White City became the model for other large-scale urban improvement projects across the country. (Courtesy Paul V. Galvin Library, Illinois Institute of Technology.)

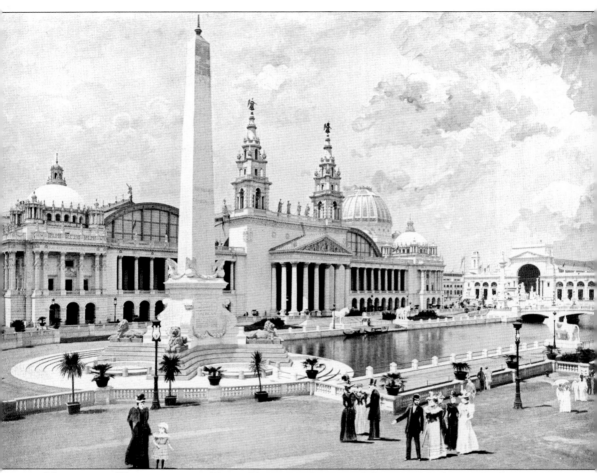

MACHINERY HALL FROM THE EAST. Above is a drawing of the great Machinery Hall's eastern façade. "It is doubtful if a more original or beautiful building was ever erected," according to *The Dream City*, a collection of fair images and commentary that was published in 1893. The Boston firm of Peabody and Stearns designed the building in the Spanish Renaissance style and was faced with the challenge of remaining true to the harmony of the White City while building an unabashed monument to industry and materialism—or "revealing the mysterious relationships between machinery and art." But with their richly adorned Corinthian colonnades, corner pavilions, sets of towers and iron arches, and rooftop statues, Peabody and Stearns was wildly successful. (Courtesy Paul V. Galvin Library, Illinois Institute of Technology.)

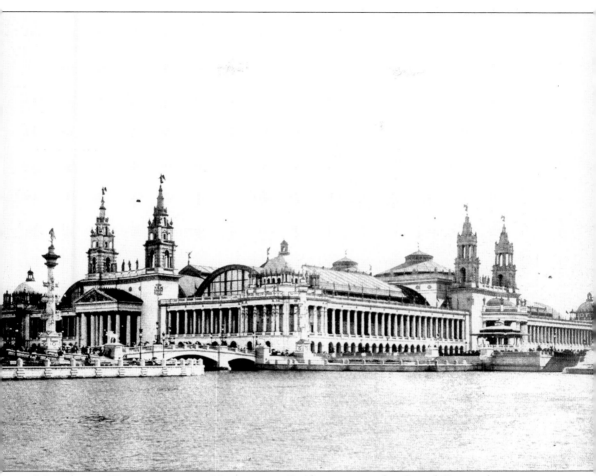

MACHINERY HALL FROM THE NORTHEAST. Looking across the Grand Basin, the eastern and northern sides of Machinery Hall are visible. The northern façade of the building was more than 840 feet long, and the entire building cost $1.2 million (of the fair's buildings, only Manufactures cost more). Despite its vast size, Machinery was less than one-third the size of Manufactures. According to *The Book of the Fair*, "the details of this design have been kept in rigid conformity with classical and scholarly traditions, relieved in parts by motives suggested by the highly ornate renaissance of Spain. Enriched profusely with sculpture and emblematic statues, and with effects of decorative color behind the open screen of the porticos, this composition . . . may at least stand as a beautiful model of highly organized academic design devoted to modern uses." (Courtesy Paul V. Galvin Library, Illinois Institute of Technology.)

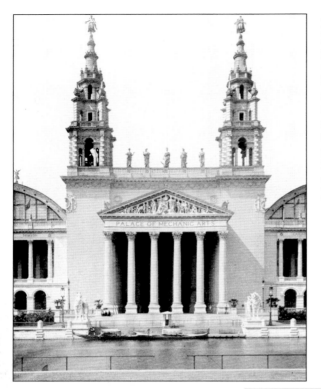

EASTERN PORTAL OF MACHINERY HALL. Fronting the south canal, this porch accented three iron arches (the middle of which is hidden behind the porch). In the pediment, eagles, lions, and figures of Honor, Genius, and Wealth surround a central figure of Columbia. Above the pediment and between the two towers are 13-foot statues of Science, Air, Earth, Fire, and Water. (Courtesy Paul V. Galvin Library, Illinois Institute of Technology.)

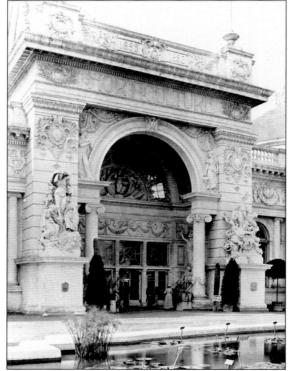

HORTICULTURAL BUILDING. The ornate design of the building is indicated by its main entrance. According to *The Book of the Fair*, "at the principal entrance, from the terrace fronting on the lagoon, is a triumphal arch, the vestibule of which is profusely decorated with statuary. . . . These are among the most chaste and expressive of all the artistic embellishments of the Exposition buildings, and standing forth in bold relief under the vault of the central dome, form the complement of the architectural design." (Courtesy Paul V. Galvin Library, Illinois Institute of Technology.)

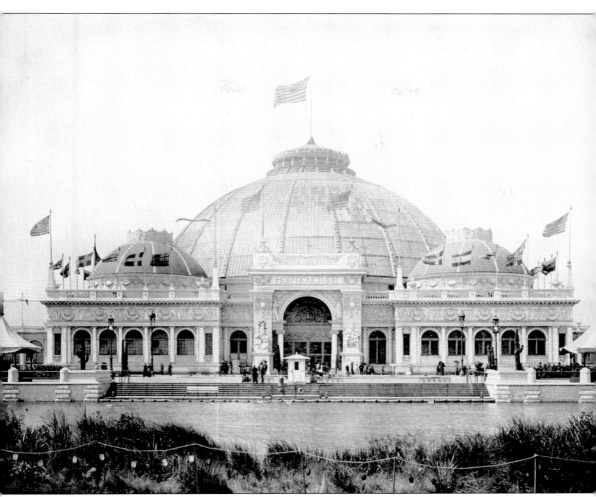

Horticultural Building. Located on the lagoon, the decorative Horticultural Building was designed in the Venetian Renaissance style by Chicago architects Jenney and Mundie. The building primarily served as a conservatory, with greenhouses, glass-roofed galleries, and exhibits of plants, flowers, wines, grasses, and fruits and vegetables from around the world, which all presented a challenge for its architecture. "It was to fulfill its office as a conservatory and yet stand creditably among the colossal halls which were required for the display of the world's industries," as was written in *The Dream City*, but the building successfully blended form and function. Inside, California exhibited a 30-foot-high tower of oranges in the shape of a column, complete with a cornice made of lemons. The Wooded Island, located directly in front of the Horticultural Building and within the lagoon (and shown in the foreground of the picture), contained the largest assortment of roses ever collected. (Courtesy Paul V. Galvin Library, Illinois Institute of Technology.)

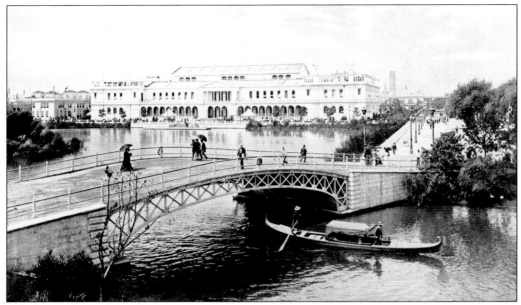

WOMAN'S BUILDING. The stature of the Woman's Building was significant to women's rights. It was entirely under control of the Board of Lady Managers, which gave women's exhibits unprecedented importance. The building also had the only design competition—for women only—and student Sophia Hayden's design won $1,000. Hayden designed the Italian Renaissance building with feminine characteristics representing spirituality and love, and the building suggested "lyric features" rather than "heroic," or masculine, aspects of the buildings dedicated to industry and science. (Courtesy Paul V. Galvin Library, Illinois Institute of Technology.)

MERCHANT TAILORS' BUILDING. This orthodox Ionic building was small but had a significant impact on religious architecture in the United States. Architect Solon Beman based his design on the structures of the Acropolis and adopted the look in his later work for the Church of Christ, Scientist. After the fair, numerous Christian Science churches modeled after the Merchant Tailors' Building were built in Chicago and other U.S. cities. (Courtesy Paul V. Galvin Library, Illinois Institute of Technology.)

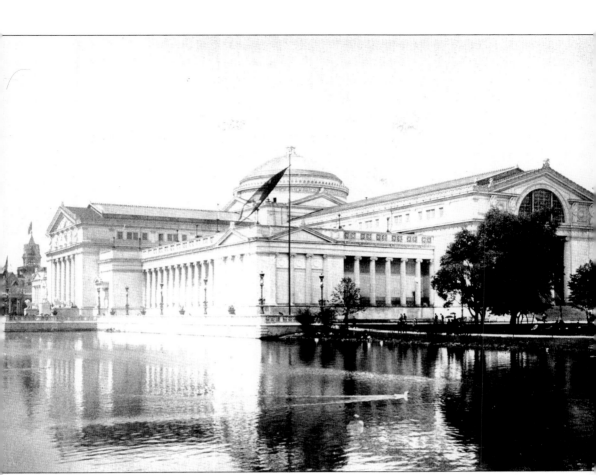

PALACE OF FINE ARTS. *The Book of the Fair* had this to say about the Palace of Fine Arts: "There is but one opinion—that it is of itself one of the most artistic features in the Exposition." Its severely classical design, by Charles B. Atwood, is modeled after that of a Greek temple and features a dome that rises 125 feet from the ground and a total of 24 caryatids on porches inspired by the Acropolis. During the fair, the building hosted some of the event's most valuable artwork from around the world, and as the one permanent building from the fair, is the only significant building that survived the post-fair destruction. The main entrances (the south entrance, shown to the left in the image, faced the North Lagoon and was reached by boat) were centered in the building's layout and were in the form of Ionic porticos. After 1893, the Palace became the original Field Museum but was abandoned and fell into disrepair when the current Field Museum opened in 1921. However, after a refurbishment led by Julius Rosenwald, the president and chairman of Sears, Roebuck and Company, the museum reopened in time for Chicago's 1933 Century of Progress Exposition, as North America's first interactive, hands-on museum. The Museum of Science and Industry has since become one of the country's leading museums and one of Chicago's top attractions. It became a Chicago landmark in 1995. (Courtesy Paul V. Galvin Library, Illinois Institute of Technology.)

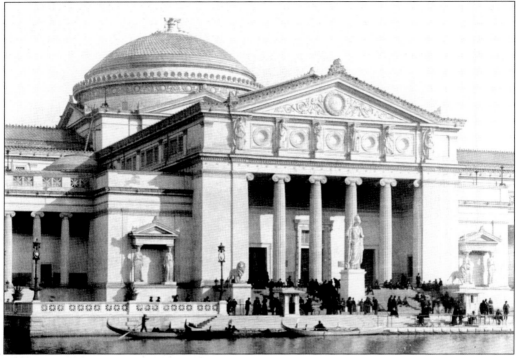

PALACE OF FINE ARTS. Fair attendees arrive by boat at the building's southern entrance. From *The Book of the Fair*: "The building was partially surrounded with a colonnade, its pillars, eight feet from the wall and nearly thirty in height, forming a covered walk or piazza extending from the central portal to the corner pavilions. To this portal broad flights of stairs, flanked by balustrades and terraces lead from a landing place on the northern arm of the lagoon." (Courtesy Paul V. Galvin Library, Illinois Institute of Technology.)

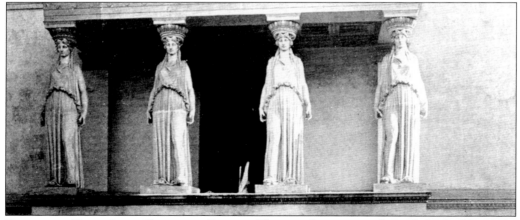

PALACE OF FINE ARTS CARYATID PORCH. This porch contains four of the building's 24 caryatids, or architectural columns in the form of a female figure. These caryatids were direct descendants of those found on the Erechtheion, a 2,400-year-old temple at the Acropolis. While the use of caryatids dates back to perhaps the sixth century B.C. and was popular in ancient Rome, they became popular again during the classical revival of the 1800s. (Courtesy Paul V. Galvin Library, Illinois Institute of Technology.)

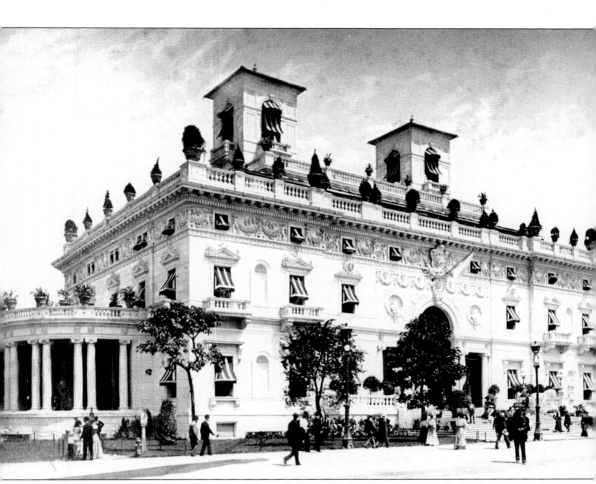

NEW YORK BUILDING. Outside of the White City but within the fairgrounds, U.S. states and territories and foreign countries erected their own buildings. Their most prominent exhibits were displayed in the Great Buildings, so the state and foreign buildings largely acted as headquarters for local officials and visitors, although they did contain exhibits as well. Because they were located outside of the White City, state and foreign buildings were not bound by the same design restrictions as the Great Buildings, although many were built in the classical style anyway. New York representatives did not accept the site granted for their building until the last minute (as they were upset by losing out as host of the fair), but New York–based McKim, Mead and White concocted a building of "palatial design." Like many other buildings that were not required to be classical, the New York Building very much conformed to the style, with an Italian Renaissance flair. But it was always assumed that this building would be classical because New York architects (McKim, Mead and White specifically) were so instrumental in creating the look of the White City. The New York Building was inspired by the Van Rensselaer mansion in lower Manhattan and Rome's Villa Medici. (Courtesy Paul V. Galvin Library, Illinois Institute of Technology.)

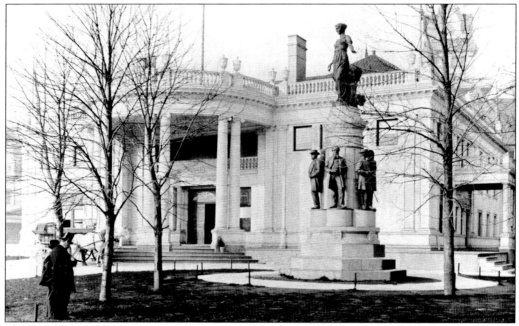

OHIO BUILDING. The front of the Ohio Building was dominated by a semicircular Ionic porch that spanned both floors of the building. The statue in the foreground was moved to the Ohio Statehouse after the fair. The figure atop of the statue is Roman matron Cornelia, who considered her sons to be her "jewels"—who in this case included Ulysses S. Grant, James Garfield, and Rutherford Hayes. (Courtesy Paul V. Galvin Library, Illinois Institute of Technology.)

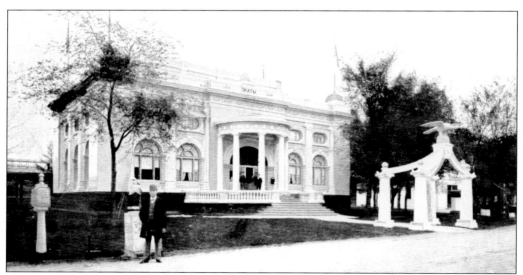

UTAH BUILDING. Utah's contribution to the fair was largely privately financed by its Mormon population, as its governor vetoed a $50,000 appropriation. As a result, the front of the building featured a statue of Brigham Young and the entranceway at the left of the photograph is a partial reproduction of the Eagle Gate in Salt Lake City. The Ionic portico is the centerpiece of the building. (Courtesy Paul V. Galvin Library, Illinois Institute of Technology.)

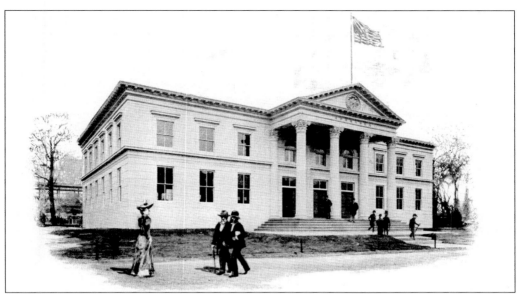

NEBRASKA BUILDING. *The Book of the Fair* described the Nebraska Building as "of the later colonial style, with massive columns and a spacious portico approached by broad flights of steps, and with the seal of Nebraska boldly executed on the architrave." The building was dedicated with help from Buffalo Bill, who was a brigadier general of Nebraska militia. (Courtesy Paul V. Galvin Library, Illinois Institute of Technology.)

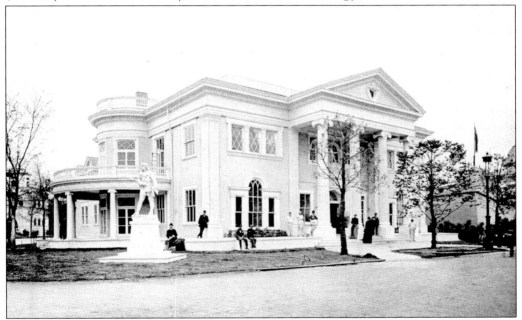

KENTUCKY BUILDING. Kentucky's submission to the fair "was typical of the style prevailing in the colonial era of the south, reproducing an old Kentucky homestead of the better class," according to *The Book of the Fair*, and its front and side Ionic porticos were clearly classical touches. The statue in the foreground is of Daniel Boone and is now in Louisville's Cherokee Park. (Courtesy Paul V. Galvin Library, Illinois Institute of Technology.)

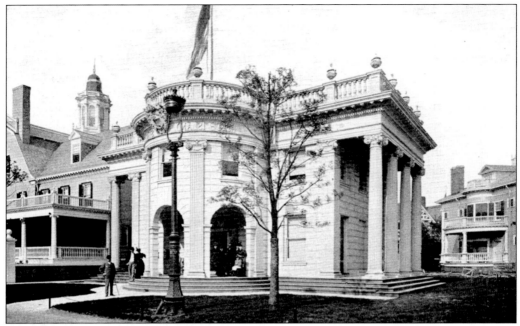

RHODE ISLAND BUILDING. This small Greek building (approximately 1,300 square feet) had its main entrance through the two-story, semicircular porch in the middle of the structure, and the two "great porches" were at the sides rather than the front and rear. A balustrade extended the length of the roof, and wide French windows opened to the verandas. (Courtesy Paul V. Galvin Library, Illinois Institute of Technology.)

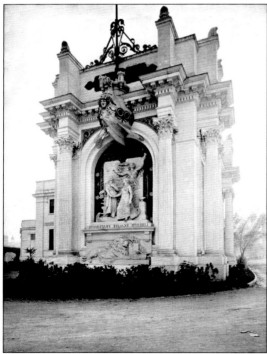

FRENCH BUILDING. This French Renaissance building, with its Corinthian columns and decorative cornice, was actually two buildings connected by a gallery. The side of the building shown here shows the "administrative machinery" of Paris, including the Bertillion method of identifying criminals based on the measurement of unchanging physical characteristics. And in contrast to the fair's overriding themes, the building shows "man's wickedness and the ugliness of bad men's faces." (Courtesy Paul V. Galvin Library, Illinois Institute of Technology.)

DESTRUCTION OF THE WHITE CITY.
On January 8, 1894, a fire destroyed the Peristyle and surrounding buildings such as the Casino, Music Hall, and the movable sidewalk. By that July, a series of additional fires destroyed the rest of the Court of Honor. Some of the fair's buildings were saved and relocated, and a few remained in Jackson Park. Only the Palace of Fine Arts (now the Museum of Science and Industry) remains. (Courtesy Paul V. Galvin Library, Illinois Institute of Technology.)

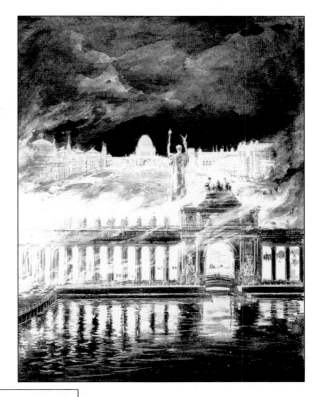

When the world beheld with pity,
As the fiery cyclone's flame
Swept across our smitten city—
Then began its greater fame.

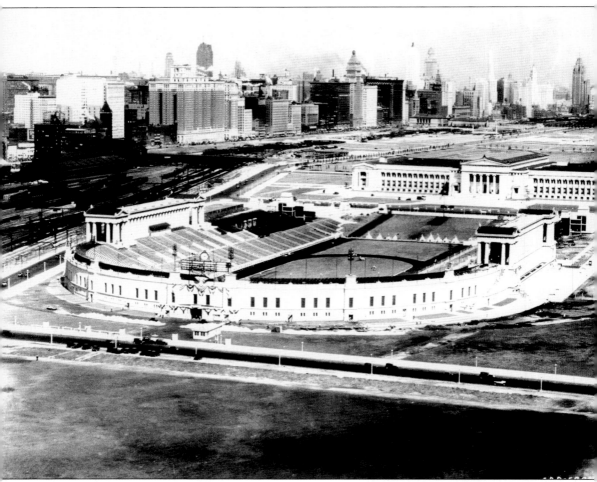

SOLDIER FIELD AND THE FIELD MUSEUM. Seen from the sky, Soldier Field and the Field Museum dominate the area just south of Grant Park, which technically ends to the north of the museum at Roosevelt Road. Soldier Field, which was built after the museum, was classically designed in order to complement the museum, and the stadium was intentionally left open at its north end to preserve the view. The open parkland behind the museum, between Roosevelt Road, Michigan Avenue, Randolph Street, and Lake Michigan contains Grant Park, and to the west of the park is the famous Michigan Avenue streetwall that features a number of historic buildings, many of which are classically designed. (Courtesy Chicago Photographic Collection [CPC 29-5771-13], Special Collections Department, University Library, University of Illinois at Chicago.)

Two

GRANT PARK

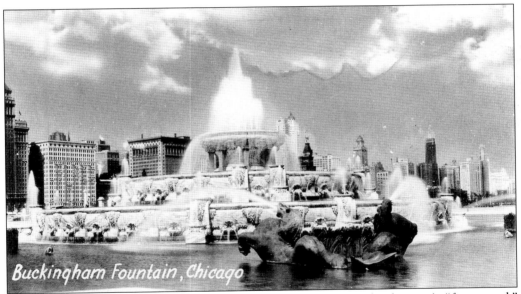

Buckingham Fountain, Chicago

BUCKINGHAM FOUNTAIN. Located in the heart of Grant Park, the city's "front yard," Buckingham Fountain is one of Chicago's best-known symbols. The fountain itself and its surrounding gardens are considered to be a significant example of Beaux-Arts landscape design and fit within the park's other great classical structures and monuments. Buckingham Fountain was donated to the city by philanthropist Kate Buckingham in memory of her brother, and when it was first turned on in 1927, it was the world's largest fountain. The structure was designed by Edward H. Bennett, who was instrumental in executing Daniel Burnham's 1909 plan (and was Burnham's coauthor), which anticipated transferring lessons from the Columbian Exposition to the entire city. From approximately April through October, the fountain's jets (which shoot water 150 feet in the air) are turned on for 20 minutes every hour from 10:00 a.m. to 11:00 p.m., with an accompanying light and music show at night. Buckingham Fountain became a Chicago landmark in 2000.

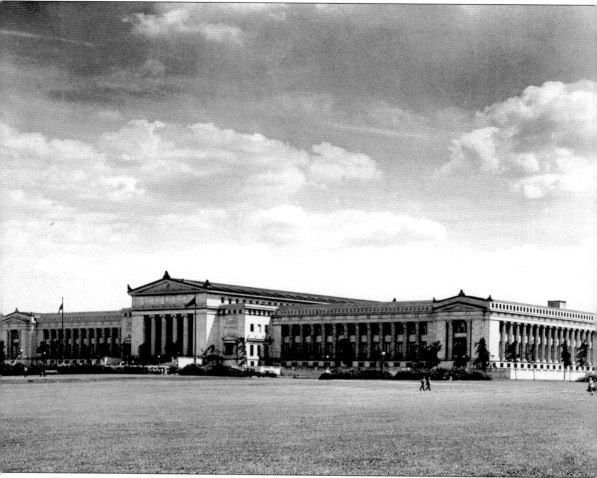

FIELD MUSEUM OF NATURAL HISTORY. The Field Museum is one of three institutions within the 57-acre lakefront Museum Campus, along with the Shedd Aquarium and the Adler Planetarium, and is immediately to the north of Soldier Field. The museum, which was designed by Burnham and named after Marshall Field, opened in 1921 after moving from its original facility, which was the Palace of Fine Arts during the Columbian Exposition and is now the Museum of Science and Industry. Burnham and Bennett's plan included the vision for the current Museum Campus, as they wrote that "the advantages of developing Grant Park as the intellectual center of Chicago cannot be overestimated; for art everywhere has been a source of wealth and moral influence." Technically, the Field Museum and the rest of the current Museum Campus were placed outside of Grant Park; Burnham's vision conflicted with the park's official designation as "public ground forever to remain vacant of buildings," and lawsuits filed by Aaron Montgomery Ward seeking to protect the park were upheld. As a result, the museums were moved south of Grant Park's southern border at Roosevelt Road. Looking southeast from Grant Park, the museum's symmetrical plan, centered on the main pavilion, is evident. (Courtesy Chicago Photographic Collection [CPC 31-286], Special Collections Department, University Library, University of Illinois at Chicago.)

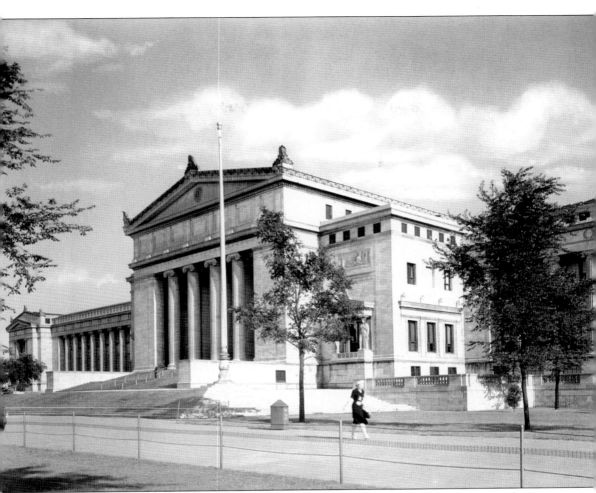

FIELD MUSEUM ENTRANCE. Like many other grand classical buildings, the museum's design was inspired by the Erechtheion, a fifth-century B.C. Greek temple at the Acropolis. A closer look to the side of the main entrance reveals two caryatids, also borrowed from the Erechtheion. The museum, made of white Georgia marble, is within steps of Soldier Field and the Shedd Aquarium, which form an impressive collection of classical architecture on Chicago's lakefront. (Courtesy Chicago Photographic Collection [CPC 41-S-188], Special Collections Department, University Library, University of Illinois at Chicago.)

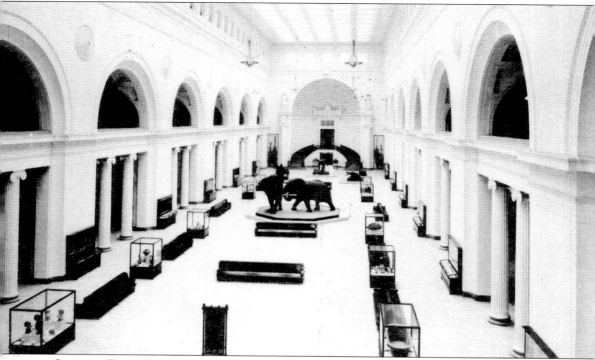

STANLEY FIELD HALL. The Field Museum's central hall, named for its former president (and Marshall's nephew), stretches the entire width of the building (nearly 300 feet) and has a 75-foot ceiling. The hall, lined by Ionic columns and grand arches, is surrounded by exhibition spaces on the museum's first floor. It is now the home of Sue, the largest, most complete, and best preserved *Tyrannosaurus rex* ever found. *The AIA Guide to Chicago* called the hall "one of Chicago's grandest neo-Classical spaces, monumental yet serene."

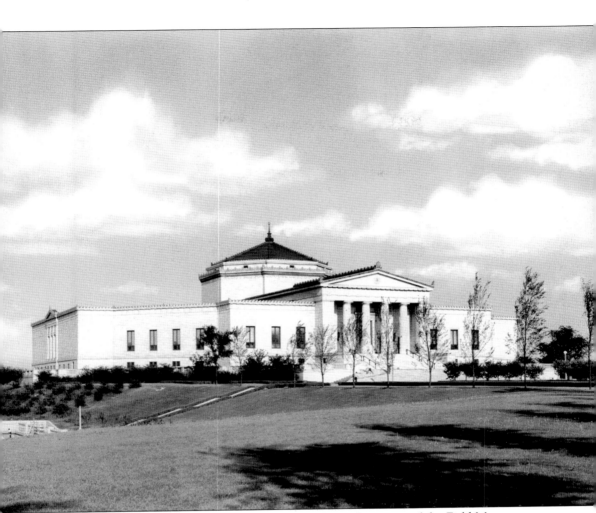

JOHN G. SHEDD AQUARIUM. The Shedd Aquarium, located just east of the Field Museum on a peninsula created by landfill from the museum's construction, opened in 1929. Its Greek-inspired Beaux-Arts design was intended to match that of its neighbor, and the facility was built by Graham, Anderson, Probst and White (a successor firm of Graham, Burnham and Company). The aquarium, which is the world's largest indoor aquarium, was a gift to the people of Chicago from John Shedd, the president and chairman of the board of Marshall Field and Company in the early 20th century. The building is shaped in the form of a Greek cross, although spaces in the corners were added to the plan, resulting in an octagon. The designers went to great lengths to add touches that are appropriate for an aquarium—"wherever consistent with the classic design, various aquatic motifs were worked in the marble and tile," according to a 1933 museum guide. On the building's exterior, cresting waves ride along cornices, the dome is topped by three dolphin tails that support Poseidon's trident, and reliefs of various sea creatures are carved into walls. (Courtesy Chicago Photographic Collection [CPC 41-S-190], Special Collections Department, University Library, University of Illinois at Chicago.)

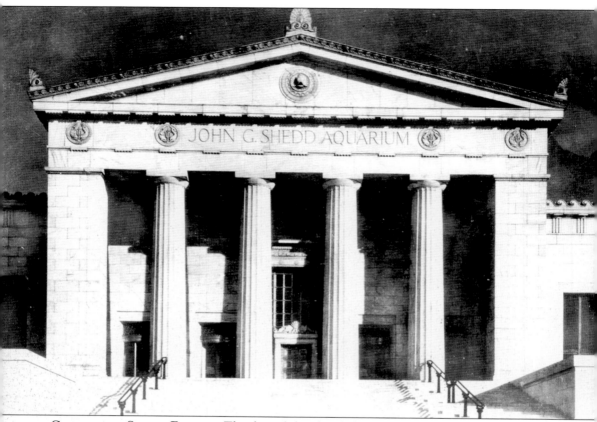

CLOSEUP OF SHEDD FAÇADE. The formal façade of the aquarium is elevated from ground level as a Greek temple would be, in order to distinguish it as an important public building. In this closeup, the aquatic themes above the Doric columns and along the cornice are more visible. In Burnham and Bennett's plan, they wrote that the lakefront "should be made so alluring that it will become the fixed habit of the people to seek its restful presence at every opportunity," and the aquarium helped to realize that goal.

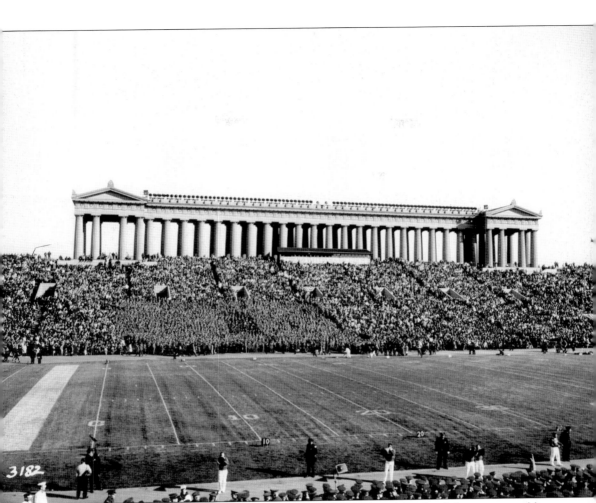

SOLDIER FIELD. Built in 1924 by the local firm of Holabird and Roche (who won a public competition that mandated a classical design), Soldier Field was one of the great public-assembly venues of the early 20th century and could host well over 100,000 people in its original configuration. Sitting on the edge of Lake Michigan and immediately south of the Field Museum, Soldier Field's simple, single-concourse design was highlighted by its two sets of Doric columns that rise 100 feet above ground level. This image shows the east colonnade during a 1963 Air Force–Army game. Although both Soldier Field and the NFL's Bears have been in Chicago since the early 1920s, Soldier Field was built as a multipurpose municipal facility rather than a football stadium, and the Bears did not call the stadium home until 1970. The stadium has hosted numerous landmark events over the years, including the 1926 Eucharistic Congress (and its 150,000 pilgrims), the Jack Dempsey–Gene Tunney "Long Count" heavyweight championship bout in 1927, the best-attended high school football game in history (115,000 people, in 1937), a Dr. Martin Luther King Jr. rally, soccer's 1994 World Cup, and even ski jumping. In 2002–2003, the facility was gutted and rebuilt to better conform with modern NFL stadium standards, although the exterior shell and colonnades remain intact. The first Bears game in the "new" Soldier Field was a Monday night contest against the Green Bay Packers on September 29, 2003. (Courtesy Chicago Photographic Collection [CPC X-3182], Special Collections Department, University Library, University of Illinois at Chicago.)

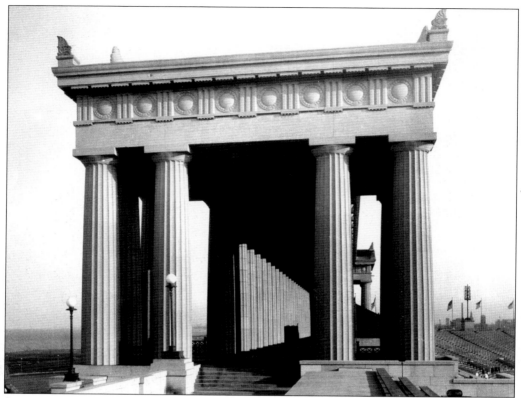

SOLDIER FIELD, EAST COLONNADE. This closeup shows an earlier view of the east colonnade, looking directly south with Lake Michigan on the left. The seating bowl of the new Soldier Field (described as an "alien toilet bowl" by the *Chicago Tribune*) rises well above the intact colonnade, and because of the extensive changes to the facility, its national historic landmark status has been threatened. (Courtesy Chicago Photographic Collection [CPC 31-101], Special Collections Department, University Library, University of Illinois at Chicago.)

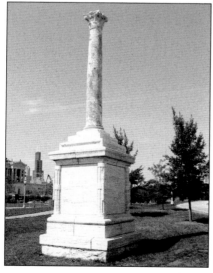

BALBO COLUMN. A single Corinthian column placed on a pedestal, located in Burnham Park, just east of Soldier Field, is one of Chicago's most overlooked (and bizarre) monuments. In commemoration of the first transatlantic crossing of the Italian air force in 1933, led by Italo Balbo with a destination of Chicago for its Century of Progress Exposition, Benito Mussolini presented this 2,000-year-old column to the city. In the background, to the left, are Soldier Field and the Sears Tower.

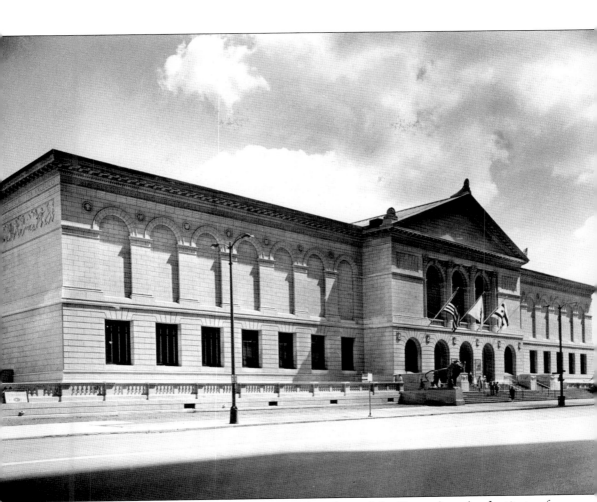

THE ART INSTITUTE OF CHICAGO. The original nucleus of the Beaux-Arts Art Institute of Chicago was designed by Shepley, Rutan, and Coolidge and was built in conjunction with the Columbian Exposition, although it is located on Michigan Avenue, seven miles north of the fairgrounds's northern edge. The Corinthian exterior is topped by an architrave with inscriptions of the names of some of history's great artists, such as Michelangelo, Da Vinci, and Botticelli, and the main entrance is guarded by two bronze lions that were added after the exposition's conclusion. The building's first use was as the host of the World's Congress Auxiliary, which held daily conferences during the fair on subjects including medicine, women's rights, commerce, art, and religion. In all, approximately 1,300 sessions were held and 6,000 addresses were given by nearly 5,000 speakers (from nearly 100 nations), including Susan B. Anthony, Clara Barton, Samuel Gompers, Burnham, and Frederick Law Olmsted, who was the fair's landscape architect. The museum now holds one of the world's best collections of impressionist art, including Seurat's *Sunday Afternoon on the Island of La Grande Jatte*. The building was added to the National Register of Historic Places in 1980. (Courtesy Chicago Photographic Collection [CPC X-2797], Special Collections Department, University Library, University of Illinois at Chicago.)

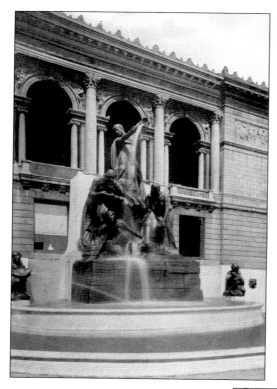

FOUNTAIN OF THE GREAT LAKES. In its first location, this Lorado Taft fountain was on the south wall of the Art Institute's original structure. Taft, a former student of the Ecole des Beaux-Arts, completed the fountain in 1913 and was inspired by a remark Burnham made to fair sculptors in 1893, when he scolded them for not making anything that honored the natural resources of the west—and in particular, the Great Lakes. In the fountain, figures represent each of the lakes.

GOODMAN THEATRE. In 1925, the Kenneth Sawyer Goodman Memorial Theatre opened behind the Art Institute in honor of the late Chicago playwright, as a gift from his parents. However, due to Grant Park's land availability and height restrictions, the entire theater, with the exception of the entrance, was built below grade by architect Howard Van Doren Shaw. The theater has since moved to the Loop, and the building was demolished in late 2005 to make way for an Art Institute expansion.

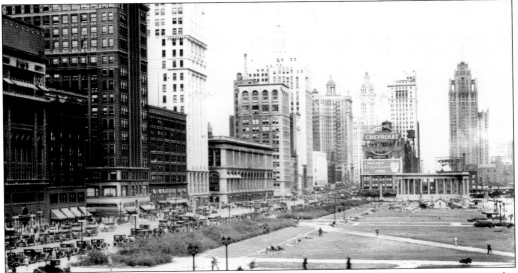

GRANT PARK PERISTYLE. In 1917, Bennett unveiled his semicircular Doric structure at the northwestern corner of Grant Park (right). Historically, peristyles line a building or a courtyard and date back nearly 3,000 years, when they first appeared in Greek temples. However, Bennett's freestanding peristyle was not linked to any other structure. The peristyle was demolished in 1953 to make way for Chicago's first underground parking lots. (Courtesy Chicago Photographic Collection [CPC M-4974], Special Collections Department, University Library, University of Illinois at Chicago.)

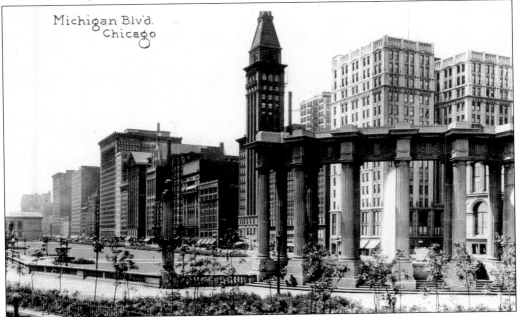

PERISTYLE. Viewed from the northeast, Grant Park's western edge bordering Michigan Avenue is visible in front of the peristyle. Also visible in the photograph is the side of the Art Institute's original Allerton Building, on the left edge, and an arched window and column of the public library between the peristyle's columns on the right.

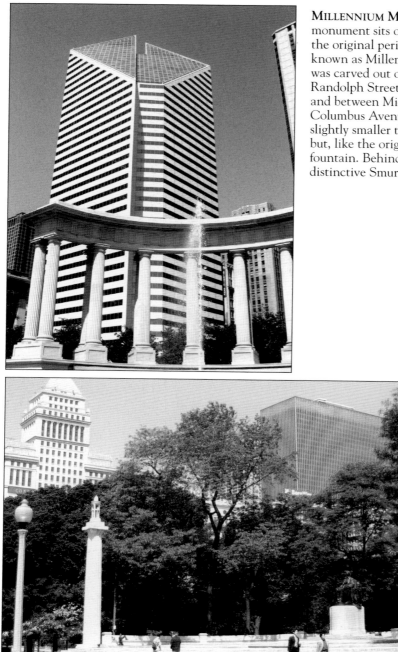

MILLENNIUM MONUMENT. The monument sits on the same site as the original peristyle in what is now known as Millennium Park, which was carved out of Grant Park from Randolph Street to Monroe Street, and between Michigan Avenue and Columbus Avenue. The structure is slightly smaller than Bennett's original but, like the original, is fronted by a fountain. Behind the monument is the distinctive Smurfit-Stone Building.

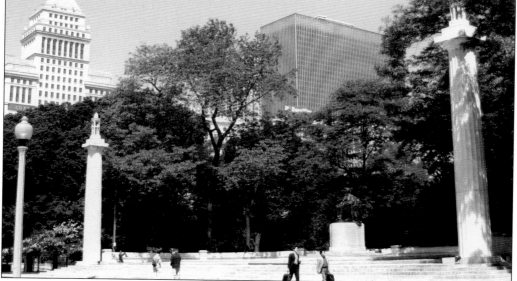

LINCOLN MONUMENT. Two large Doric columns guard this statue of Abraham Lincoln in Grant Park. *Sitting Lincoln*, as this one is known, is one of Chicago's five Lincoln monuments—the others being *Standing Lincoln* in Lincoln Park, *The Railsplitter* in Garfield Park, *Young Lincoln* in Senn Park, and *Chicago Lincoln* in Lincoln Square. *Standing Lincoln* and *Sitting Lincoln* were created by Augustus Saint-Gaudens, who earlier designed the Columbian Exposition's Statue of Diana atop the Agricultural Building.

44

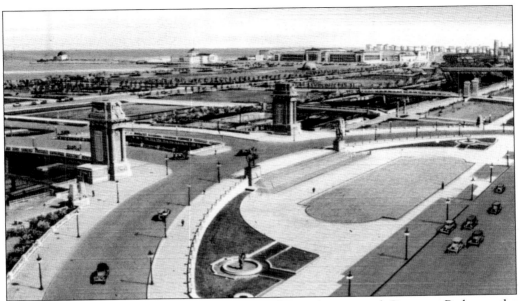

GRAND PLAZA, GRANT PARK. Located at Michigan Avenue and Congress Parkway, the semicircular plaza leading into Grant Park has since been bisected by Congress, and the stairwell no longer exists. The two monuments at the edge of the park, each with its Tuscan columns, were inspired by the Renaissance, which expanded classical design into landscapes and gardens.

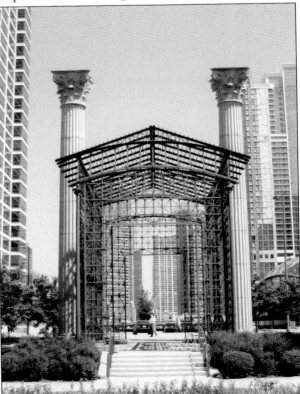

CANCER SURVIVORS PLAZA. Located at the northeastern edge of Grant Park near Randolph Street and Lake Shore Drive, the plaza is one of 18 U.S. monuments that were funded by the late Richard Bloch, who cofounded H&R Block and suffered from lung cancer. The twin 45-foot Corinthian columns, which are the centerpiece of the plaza that was dedicated in 1996, are remnants from the former post office, customs house, and subtreasury building, which was built more than 100 years ago and demolished in the mid-1960s.

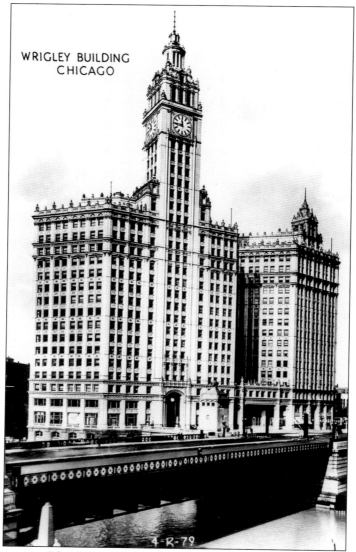

WRIGLEY BUILDING
CHICAGO

4-R-79

WRIGLEY BUILDING. The home of the chewing gum empire is one of Chicago's most distinctive buildings and is on one of its highest-profile sites. It is located on the northern bank of the Chicago River and the southern edge of Michigan Avenue's "Magnificent Mile" and is on the approximate site of the city's first settlement. The Wrigley Building is actually two buildings, connected by three walkways (one at ground level, one at the third floor, and one at the 14th floor), and was completed in 1924 by Graham, Anderson, Probst and White. The building owes its sparkling white color to approximately 250,000 glazed terra-cotta tiles that are illuminated at night and reproduce "the dazzling effects of the 1893 White City," according to *The AIA Guide to Chicago*. The effect is enhanced by the use of various shades of the white tiles, with brighter shades toward the top of the building. When construction began in 1920, the Michigan Avenue Bridge (foreground) had not yet been built, and the Wrigley Building became the first major office project to the north of the river. With its classical and Renaissance forms, the building is a great combination of traditional architecture from Burnham's era and the modern office towers that were being built in the 1920s.

Three

MICHIGAN AVENUE AND LAKE SHORE DRIVE

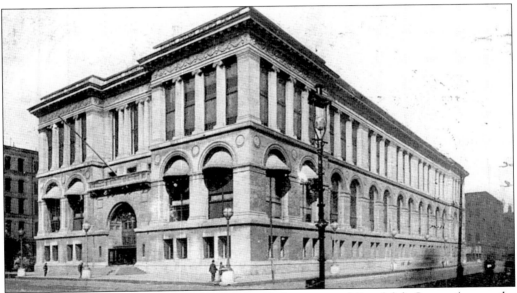

CHICAGO PUBLIC LIBRARY. Located between Washington and Randolph Streets (across the street from Millennium Park), the city's original post-fire main library was built by the Boston firm of Shepley, Rutan and Coolidge (as was the Art Institute down the street). The building was planned to open for the 1893 Columbian Exposition, and its Beaux-Arts design matched that of the White City, but problems delayed the project for four years. From 1897 through 1991, the building was Chicago's main library but became the country's first free municipal cultural center with the opening of the Harold Washington Library in the South Loop. The "People's Palace," now known as the Chicago Cultural Center, features art-related programs and exhibitions and has multiple performance spaces. It is part of the Historic Michigan Boulevard District, which stretches from Eleventh Street to Randolph Street, and faces Grant Park (about one-third of the district's 45 properties are either national or city landmarks). The building was added to the National Register of Historic Places in 1972 and became a Chicago landmark in 1976.

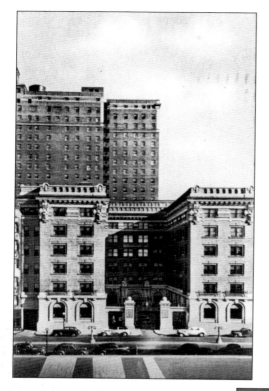

GEORGE SMITH MEMORIAL BUILDING. This building, part of the former St. Luke's Hospital, was built in 1907 for Chicago's rich and powerful (and sick), and it was designed by Charles Frost to resemble a luxury hotel. The building has Renaissance and classical touches, such as the arched windows, two large piers that front the sidewalk, and a cornice and balustrade at the roofline. The building is listed on the National Register of Historic Places and has been converted into condominiums.

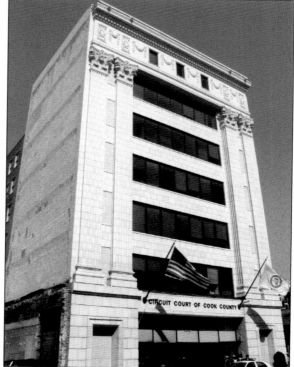

CIRCUIT COURT OF COOK COUNTY. Located at 1340 South Michigan Avenue, this courthouse is highlighted by two sets of five-story Corinthian pilasters that rise from the building's base. The stark-white building is framed at the top by a cornice. This area of South Michigan Avenue was once lined with elegant homes, but when the city's wealthier residents began to move to the North Side, they were replaced with buildings such as auto and furniture showrooms, and this building was converted into a county courthouse.

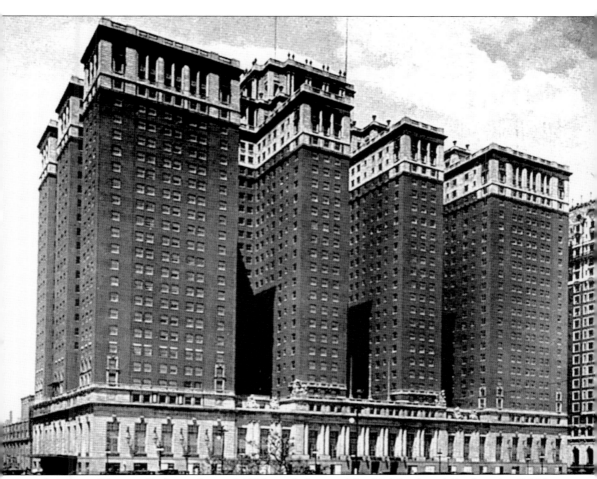

STEVENS HOTEL. Built in the mid-1920s and designed by Holabird and Roche, the 3,000-room Stevens on the 700 block of South Michigan Avenue was, at the time of its opening, the largest hotel in the world. The 25-story hotel also had an 18-hole rooftop golf course and its own hospital. The grandeur of the building was also helped by its French classical exterior and various interior spaces, such as the Grand Ballroom and Grand Stair Hall, which were inspired by Versailles. But the hotel's opulence was both a blessing and a curse; according to a *Time* article in 1943, "Chicago hotelmen have a saying that no one can make money on the Stevens Hotel but no other Chicago hotel can make money while the Stevens is running." By 1932, the hotel was in receivership, largely because of the Depression, and it went bankrupt in 1936, but the building has been restored to its original condition and is now known as the Hilton Chicago and Towers.

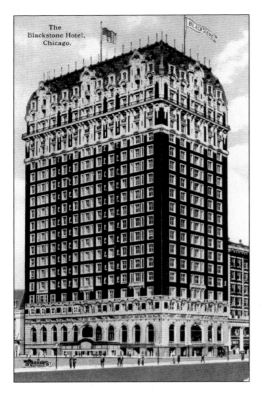

BLACKSTONE HOTEL. The landmark hotel, at 636 South Michigan Avenue (immediately north of the Stevens Hotel), was built by Marshall and Fox and is a rare example of the modern French style of Beaux-Arts classicism. It was a leading early-20th-century luxury hotel and known as "the Hotel of Presidents," from Wilson to Kennedy, but closed in 1999. Maharishi Mahesh Yogi, the Beatles' former spiritual advisor, then bought the hotel, which is now being converted into condos.

BLACKSTONE THEATRE. After its opening on New Year's Eve 1910, the theater quickly became a top destination for touring plays and events. The French Renaissance building is located to the immediate west of the Blackstone Hotel (just off Michigan Avenue), which opened earlier that year. The theater was built by Marshall and Fox, as was the hotel, and originally contained 1,400 seats. More recently, the theater was purchased by DePaul University and has been renamed the Merle Reskin Theatre.

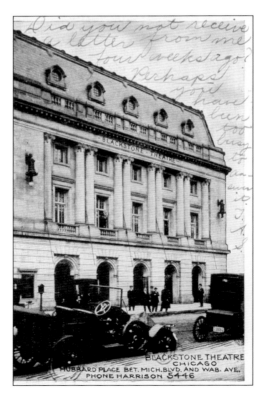

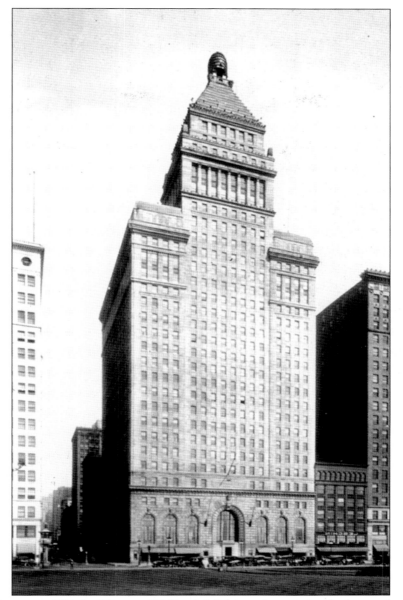

STRAUS BUILDING. This building, at 310 South Michigan Avenue, has had a number of names over the years, including Britannica Centre (it was the headquarters of Encyclopedia Britannica). However, its original tenant was S. W. Straus and Company, an investment firm, and the building was designed by Graham, Anderson, Probst and White in a manner similar to Chicago's LaSalle Street banks. The beehive ornament at the top of the building is supported by the heads of four American bison, symbolizing the interior of the country from which Straus drew its strength. At night, the pyramidal tower resembled a lighthouse, with bright lights pointing in the four cardinal directions, but the power of the light has since been turned down. The building opened in 1924 as the city's first building with more than 30 floors. It was recently converted to condominiums and is now known as Metropolitan Tower. (Courtesy Chicago Public Library, Special Collections and Preservation Division.)

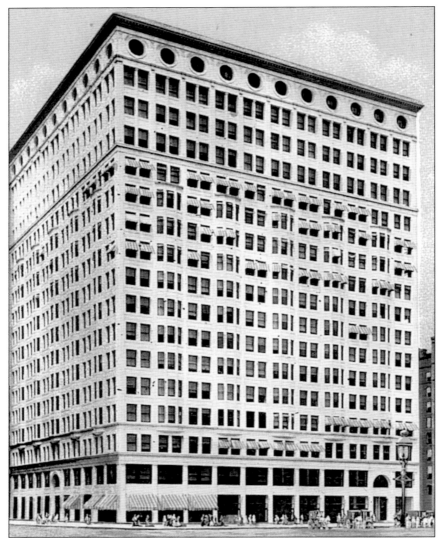

RAILWAY EXCHANGE BUILDING. Built by Burnham and completed in 1904, South Michigan Avenue's Railway Exchange Building (now known as the Santa Fe Building) is one of his most successful designs. As with his other 20th-century skyscrapers, Burnham here adapted his more traditional classical designs to mesh with new technologies and building styles. With the Railway Exchange Building, he created a practical, high-rise office tower that also had a level of decoration and beauty that added to the greater public good, particularly with its white brick and terra cotta that sparkled compared to its industrial surroundings and recalled the look of the White City. The main section of the building features projecting bays, and a row of porthole windows is below the cornice. Classical details include Greek fretwork on spandrels at the entrance and carvings of urns and goddesses. Not only did Burnham office in the building once it opened (he created his *Plan of Chicago* there), but he also owned a share of the building. Inside, the building's square, two-story open court has a grand staircase and is highly classical, with columns, pilasters, and balustrades throughout, and is topped by a skylight. Today, the building is the headquarters of the Chicago Architecture Foundation, which uses the atrium as exhibition space.

PEOPLE'S GAS BUILDING. Directly across the street from the Art Institute at Michigan Avenue and Adams Street, the People's Gas building was completed by Burnham in 1910, the year after his plan was published. The terra-cotta building is likely exactly what Burnham had in mind for Chicago and the City Beautiful movement, with its high level of detail and two separate levels of Ionic columns, at ground level and just below the cornice.

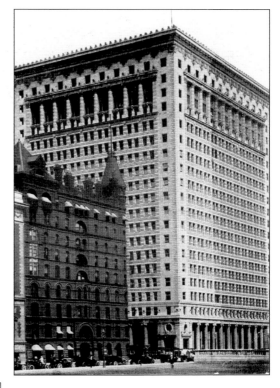

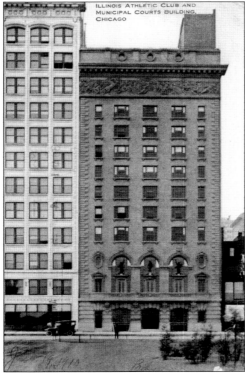

ILLINOIS ATHLETIC CLUB. Now used by the School of the Art Institute, the building is located just south of Monroe Street on Michigan Avenue. It was built in 1908 as a social and athletic club and was home of the "world's greatest swimming team," led by Johnny Weissmuller, who became an Olympic champion and movie star (as Tarzan). In 1985, a 6-story addition was built atop the original 12-story structure. The frieze at the top of the original building shows Zeus presiding over athletic competitions.

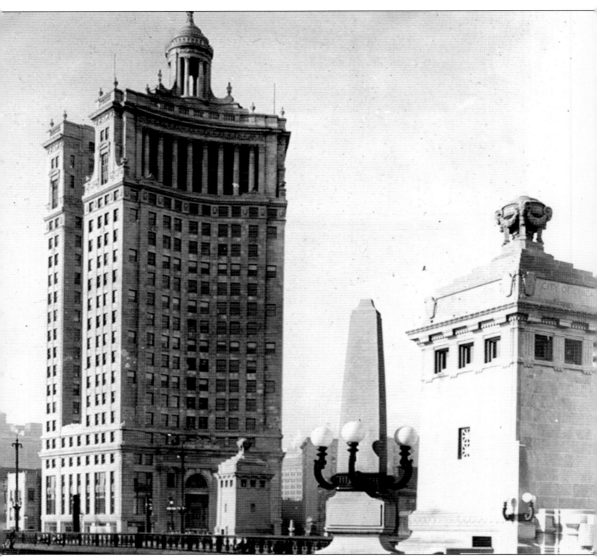

LONDON GUARANTEE AND ACCIDENT BUILDING. This building, now better known by its address (360 North Michigan Avenue), was built as the U.S. headquarters of the British insurance company in 1922 and 1923 by Alfred S. Alschuler. The structure is made of Indiana limestone and is consistent with the Burnham-Bennett plan, which envisioned Beaux-Arts development on the riverfront. Classical touches include the three-story Corinthian columns at the entrance, eight similar columns above the 15th floor, statues of Neptune and Ceres, Greek meander patterns, and a Greco-Roman tempietto on top that resembles the Choragic Monument in Athens. The London Guarantee Building, the Wrigley Building, Tribune Tower, and 333 North Michigan were the four main projects along the newly built Michigan Avenue Bridge in the early 1920s that connected North Michigan Avenue with the Loop. The building sits on the site of Fort Dearborn (the major western U.S. military outpost in the early 19th century), which later became a high-profile lot at the corner of Michigan Avenue and Wacker Drive, and was designated as a Chicago landmark in 1996. (Courtesy Chicago Public Library, Special Collections and Preservation Division.)

OLD REPUBLIC BUILDING. The building was completed in 1925 by Vitzhum and Burns as the Bell Building but was bought by the Old Republic Life Insurance Company in 1957. It is a classical skyscraper in every aspect. Its granite base has a grand entrance suggesting a triumphal arch, and the terra-cotta shaft is topped by a colonnade and cornice. The building was the first high-rise built east of Michigan Avenue and south of the Chicago River. (Courtesy Old Republic International.)

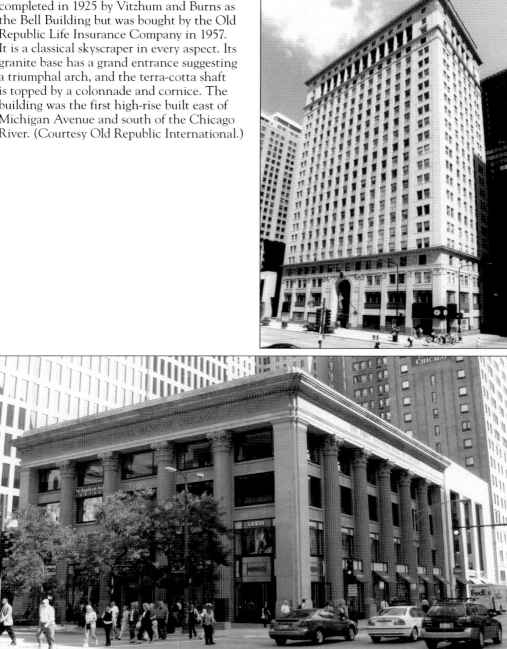

LAKE SHORE TRUST AND SAVINGS BANK. The former bank was designed by Marshall and Fox and was completed in 1922 at the corner of Michigan Avenue and Ohio Street, which is now in the heart of the Magnificent Mile. The limestone façade's full-height columns eliminate the use of pediments or other design features typical of a classical building, and the retail signage and tinted windows, which replaced the original windows, give the building a slightly modern feel.

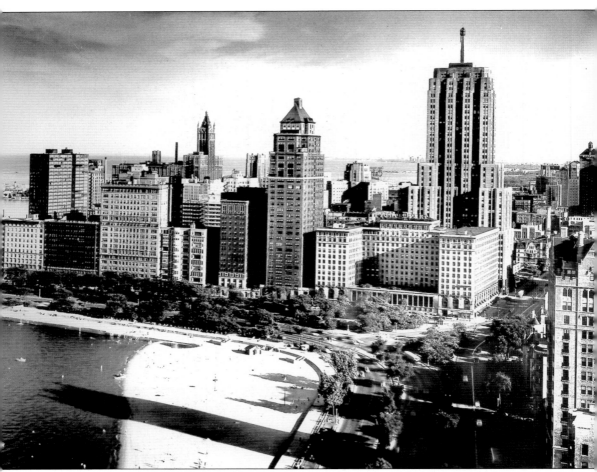

THE DRAKE HOTEL. Since 1920, the Drake (at the right center of the photograph) has occupied one of Chicago's most high-profile sites, sandwiched between Michigan Avenue and Lake Shore Drive, and facing Oak Street Beach and Lake Michigan, in the Gold Coast. The 537-room hotel was designed by Ben Marshall of Marshall and Fox, and before its opening, the *Economist* reported that it would be "of unusual magnificence, nothing like it in appearance, arrangement or finishing having ever been attempted in this country." The Italian Renaissance building has a rectangular base that rises three floors (with a colonnaded northern façade) before giving way to an H-shaped structure for the top 10 stories. Marshall designed the Drake with a piano nobile, a Renaissance feature that brings the main floor and public rooms above ground level. For decades, the Drake has been the hotel of choice for visiting celebrities ranging from Princess Diana and Winston Churchill to Salvador Dali and Bob Hope to Presidents Hoover, Eisenhower, Ford, Reagan, and Clinton. In 1981, the Drake was added to the National Register of Historic Places. The building is also part of Chicago's East Lake Shore Drive Historic District (along with seven residential buildings to the east), a result of early-20th-century development that exemplified luxury living in Chicago and presented a formal and consistent streetscape with historical design elements from Italy, France, and England. (Courtesy the Drake.)

EAST LAKE SHORE DRIVE HISTORIC DISTRICT. For a brief stretch (beginning with the Drake), Lake Shore Drive runs east to west, and the eight buildings on East Lake Shore Drive became a landmark district in 1985. Built between 1912 and 1929 by Marshall and Fox, and Fugard and Knapp, most of the buildings on the street have strong classical influences. Shown here is the entrance to the Breakers at 199 East Lake Shore Drive, built by Marshall and Fox in 1915 in terra cotta and red brick.

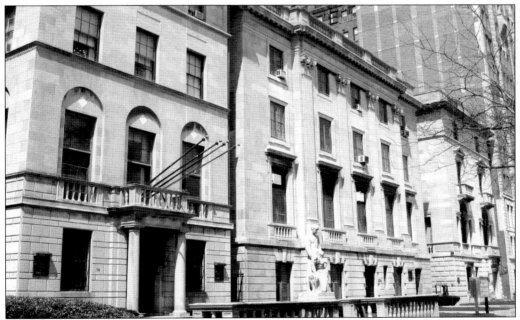

NORTH LAKE SHORE DRIVE HISTORIC DISTRICT. Seven buildings on the 1200 and 1500 blocks of North Lake Shore Drive became city landmarks in 1989. The buildings, built between 1889 and 1917, are rare surviving mansions from the street's early residential development. The three former homes on the 1500 block are now the International College of Surgeons (ICS) headquarters, the ICS Museum, and the Polish Consulate. The museum is Howard Van Doren Shaw's four-story reproduction of Versailles's Petit Trianon.

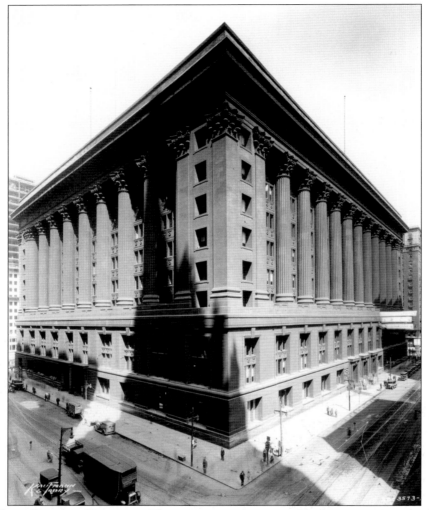

CITY HALL-COUNTY BUILDING. The imposing, one-square-block structure in the Loop is shared by the City of Chicago (the western side of the building) and Cook County (east), and seems appropriate for "the City of Big Shoulders." The building was completed in 1911 by Holabird and Roche and is the seventh shared city and county building on the site, dating back to 1853. It anticipated the more disciplined classicism sanctioned by Burnham and Bennett's 1909 plan and made popular by the Columbian Exposition. The two planners proposed a grand but unrealized civic center complex with Beaux-Arts city, county, and federal buildings at Congress Parkway and Halsted Street, but this joint city-county building was built instead. Massive Corinthian columns rise from a formidable base to support a massive cornice (which, like many others, was later trimmed back for safety reasons), and four granite relief panels—symbolizing city playgrounds, public schools, the park system, and the water supply system, the four great features of municipal government—flank the entrance. Since 2000, the roof of the city's side of the building has been "green"—a 20,000-square-foot garden was planted in order to improve air quality, conserve energy, and reduce storm water runoff, as part of Chicago's Urban Heat Island Initiative. The city and county building became a Chicago landmark in 1982. (Courtesy Chicago Photographic Collection [CPC 28-3573-5], Special Collections Department, University Library, University of Illinois at Chicago.)

Four

THE LOOP AND
DOWNTOWN

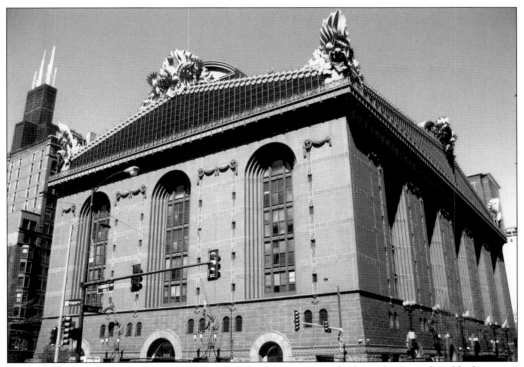

HAROLD WASHINGTON LIBRARY CENTER. The library, named after Chicago's first black mayor, opened in 1991 and succeeded the current Cultural Center as the city's main branch. The neoclassical building, located in the South Loop, mixes classical touches with brick, glass, and stone, and was designed by Thomas Beeby, who has said that the library looks "like other buildings you see in Chicago," such as the city-county building, the Cultural Center, and the Art Institute.

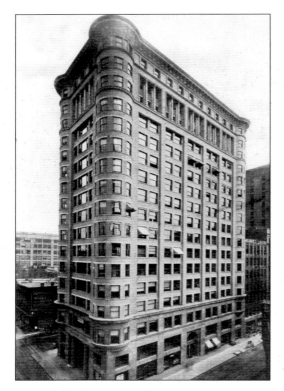

OLD COLONY BUILDING. Built at 407 South Dearborn Street in 1894 and designed by Holabird and Roche, the Chicago landmark is a leading example of the Chicago school of architecture, which was considered a modern form and led to the first skyscrapers. However, Beaux-Arts touches are evident in the façade's three-part organization: a definitive base, a long unornamented midsection, and a top enriched with a two-story colonnade leading to a final story supporting a projecting cornice.

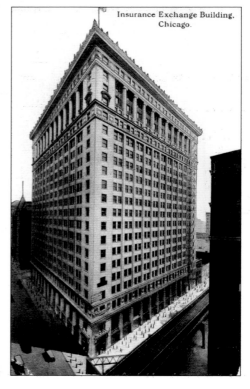

Insurance Exchange Building, Chicago.

INSURANCE EXCHANGE BUILDING. Located on West Jackson Boulevard, the Insurance Exchange Building was once home to more insurance companies than any other building in the world. The current structure was completed in two phases—the first (shown here) in 1912 by D. H. Burnham and Company and an expansion in 1928 by Graham, Anderson, Probst and White. Elements typical of a classical skyscraper include the explicit base and top (both colonnaded) and a relatively plain midsection, which gives the building a definitive beginning, middle, and end.

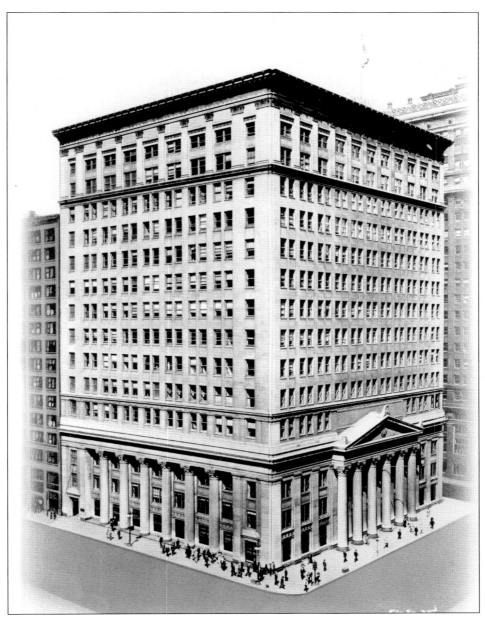

FEDERAL RESERVE BANK OF CHICAGO. The Chicago Fed—designed by Graham, Anderson, Probst and White and opened in 1922—is one of 12 regional Federal Reserve banks in the country. According to a local newspaper article at the time of the building's opening, its colonnade of 65-foot Corinthian columns was meant to produce "the impression of dignity and strength, in harmony with the power and purpose of the institution." LaSalle Street is Chicago's financial capital and the historical home of its most significant banks. The Fed and the Continental Illinois Bank Building directly across the street from it (which has its own classical façade that faces the Fed's) are at the southern end of the Loop's stretch of LaSalle Street. (Courtesy Chicago Photographic Collection [CPC 51-S-35], Special Collections Department, University Library, University of Illinois at Chicago.)

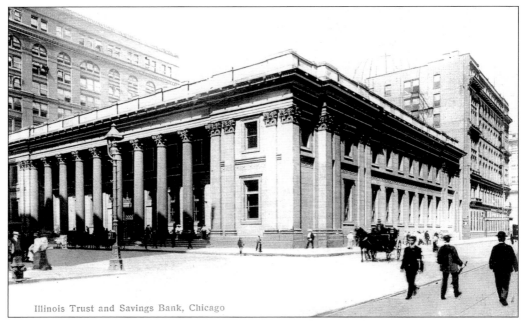

Illinois Trust and Savings Bank, Chicago

ILLINOIS TRUST AND SAVINGS BANK. This bank was demolished in 1924 and is now the site of the Continental Illinois Bank/Bank of America building, directly across the street from the Fed. The low-slung building, with its Corinthian façade, is unfortunately remembered for a July 1919 accident in which the *Wingfoot*, one of the first commercial blimps, crashed through the bank's roof after arriving in Grant Park from the South Side. The tragedy killed 10 bank employees and nearly 30 others.

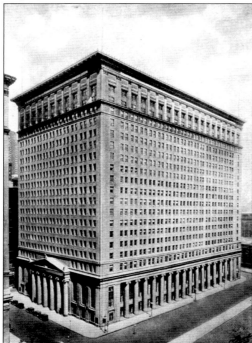

CONTINENTAL ILLINOIS BANK. Built in 1931 and located across the street from the Fed, the building replaced the Illinois Trust and Savings Bank that previously occupied the site. The building, which became known as "Chicago's Temple of Commerce" and now houses Bank of America's Chicago headquarters, was designed by Graham, Anderson, Probst and White, and its Ionic portico on LaSalle Street is directly opposite the Fed's Corinthian façade. Colonnades also line the building's southern and eastern sides.

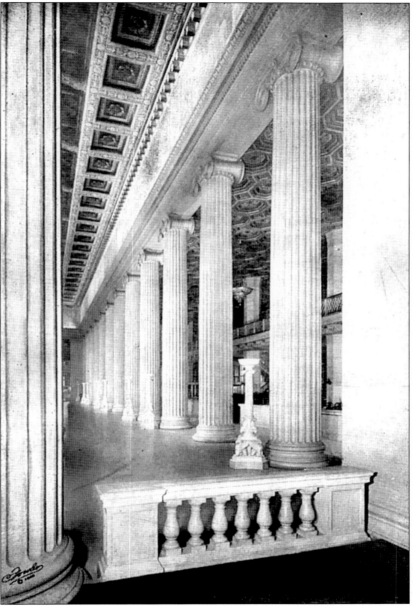

CONTINENTAL ILLINOIS' GRAND BANKING HALL. The building's main attraction, the Grand Banking Hall, rises nearly four floors (53 feet) from the second floor and is believed to have been the world's largest banking hall. The space contains 28 massive Ionic columns made of light pink Cunard marble from northern Italy, and above the columns is a series of murals titled *A Testimonial to World Trade* (by Jules Guerin, who illustrated *Plan of Chicago*), which depicts scenes from the 1893 fair. The space is so ornate and classical that Louis Sullivan, a longtime critic of the style of architecture, suggested that the bankers should wear togas and speak Latin. The Burnham Club at the west end of the hall features 16th-century oak wall panels from an English manor that were bought by Marshall Field, a bank director, in 1928. The hall was refurbished in 1993 but now houses offices and is no longer open to the public.

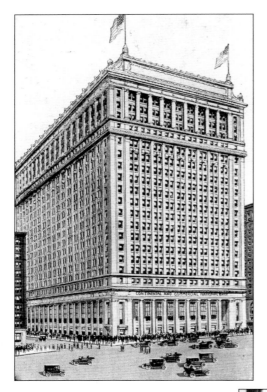

CONTINENTAL AND COMMERCIAL BANK.
Also formerly known as the City National
Bank, this building is now better known simply
by its address (208 South LaSalle Street). Its
street-level Doric colonnade gives the building
the classical look of its financial neighbors,
and the colonnade is repeated at the top of the
bank. The building was originally designed by
D. H. Burnham and Company beginning in
1912 and was completed by Graham, Burnham
in 1914.

STATE BANK OF CHICAGO. Built in
1928 by Graham, Anderson, Probst
and White, the building (at 120 South
LaSalle Street) is another in the
line of classically designed financial
institutions on LaSalle Street,
although its colonnade consists of
just four Ionic columns at the main
entrance. In 1946, the bank (which
was Exchange National Bank at the
time) opened the country's first drive-
in banking windows.

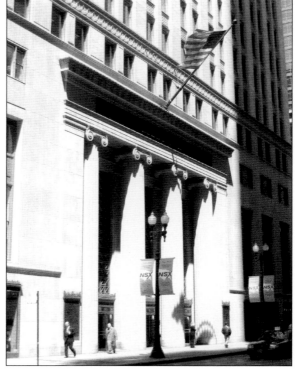

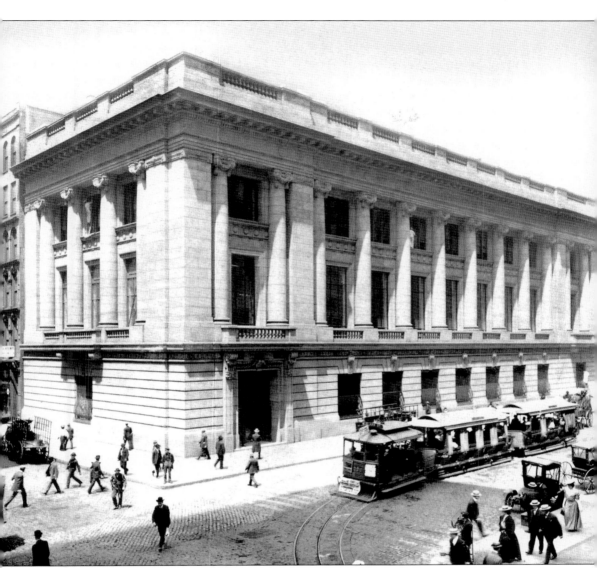

NORTHERN TRUST. The Northern Trust Company first opened for business in 1889 and, four years later, was invited to open a branch bank at the World's Columbian Exposition. Not long after the fair, the company needed more space and bought this lot at the corner of LaSalle and Monroe Streets in 1904. The headquarters building opened in 1906 (as shown here), and at the time, the building was located at the geographical center of Chicago commerce, halfway between the north–south axis of the Stock Exchange and Board of Trade, and with the city's wholesale district to the west and the retail district to the east. The building, designed by Frost and Granger and partially made of granite and marble, was built to last; years after its opening, city engineers declared the structure sag-proof and began to mark the height of all other buildings against a benchmark inserted into the building's cornerstone. One hundred years later, Northern Trust still occupies the building, although an expansion to the west also houses bank offices. Even with two floors added above the original structure in 1928, this is still the only banking house on LaSalle Street without an office tower above it. (Courtesy Northern Trust.)

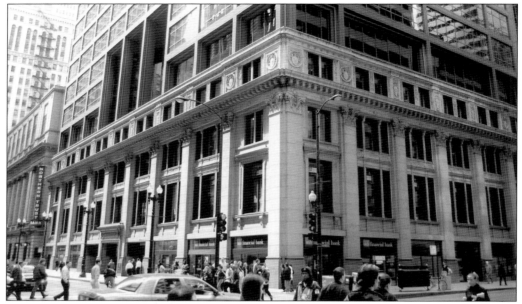

OTIS BUILDING. Originally built in 1912 at LaSalle and Madison Streets and designed by Holabird and Roche, the Otis Building became the modern Chase Plaza in the mid-1980s. However, in order to keep the look and scale of its neighbors, the first four floors of the original, classical building were preserved. The upper 33 floors now feature painted aluminum and colored glass, but the first four retain the original granite and terra cotta.

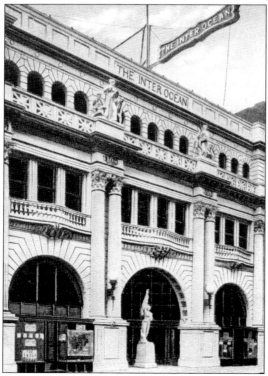

INTER-OCEAN BUILDING. In 1900, the *Inter-Ocean*, a Chicago newspaper (from 1872 to 1914), relocated to this building at 57 West Monroe Street by W. Carbys Zimmerman, who drew on the Parisian classicism that was more lush than the more formal version of the fair. Its Corinthian columns, arches, balustrades, statues, and bright coloring were meant to convey that everything was up-to-date in the newspaper. The building was later remodeled into a theater and was eventually demolished.

HARRIS TRUST AND SAVINGS. The 21-story bank (on the left) was built just off the corner of LaSalle and Monroe Streets by Shepley, Rutan and Coolidge in 1911. In 1960, Harris merged with Chicago National Bank (to the right), and the Chicago National Bank building and the one to Harris's left were both eventually replaced by more modern, international-style Harris office towers. The main entrance of the original "central" building is highlighted by four red granite Ionic columns that front deeply recessed windows.

CHICAGO NATIONAL BANK. With its highly classical façade, the Chicago National Bank fit in with its neighboring banks on LaSalle Street, although it was located on the 100 block of West Monroe Street, just around the corner from LaSalle and next door to the classical Harris Trust and Savings. The bank later became part of Harris, and the site is now occupied by a 27-story, steel-and-glass Harris office tower.

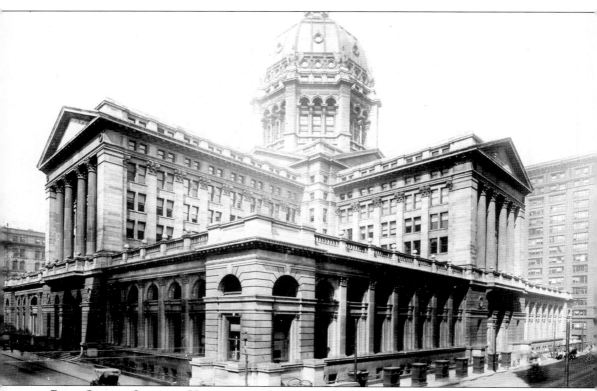

POST OFFICE, CUSTOMS HOUSE, AND SUBTREASURY. This building was known by other, less formal names such as the federal building and was built between 1898 and 1905 by architect Henry Ives Cobb. The square-block building was bounded by Dearborn, Adams, and Clark Streets and Jackson Boulevard in the Loop and was called "perhaps the best example of Beaux-Arts classicism in downtown Chicago" in the Historic American Buildings Survey shortly before its demolition in 1965. It was also called "a poem in stone" by one early-20th-century writer. The third through eighth floors of the building formed a Greek cross and were topped by an ornate dome. The building was dedicated on October 9, 1899, on the 28th anniversary of the Chicago Fire, by Pres. William McKinley in one of his last official acts before being assassinated. From the northwest corner of Adams and Dearborn Street at certain times in the afternoon, the combination of shadows and the dome's design exposed a hidden image of Uncle Sam on the dome's face. While the building was demolished to make way for a new federal building (a modernist Ludwig Mies van der Rohe design), two columns from one of its upper porticos have been resurrected and are now in Grant Park as part of Cancer Survivors Plaza.

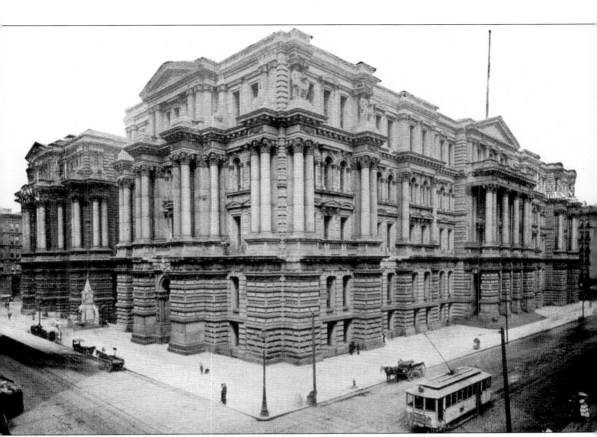

CITY HALL, 1885–1908. The predecessor to the current building, the sixth city hall occupied the same site as today's city hall-county building and was also shared with Cook County. Neither the city nor the county liked the design that won an architectural competition for this building, so they paid the winner but went ahead with their own plan, in a "colonnaded French Renaissance style," according to the federal government's Historic American Buildings Survey. The use of the classical elements on this building typify the undisciplined classicism of Chicago's pre–Columbian Exposition architecture. The entire building took approximately three years to complete and was fully occupied by both the city and county in 1885. However, because the building took so long to complete, it was essentially obsolete by then, as the city and county had already outgrown the facilities. In addition, the interior design of the building was inconvenient and uncomfortable for its users, with its small windows, oddly sized offices, and dark corridors. A gas explosion on the county's side of the building in 1905 led to its demolition and the construction of the current facility.

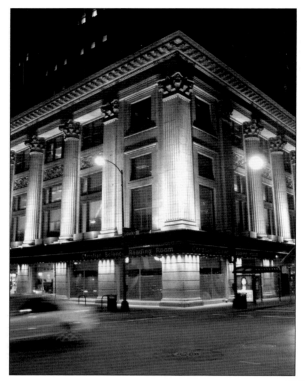

COMMERCIAL NATIONAL BANK.
Also known as the Edison Building, this Burnham design is at the corner of Clark and Adams Streets in the Loop. The building was constructed in 1905, and its Corinthian façade fit in well with its financial neighbors one block west on LaSalle Street.

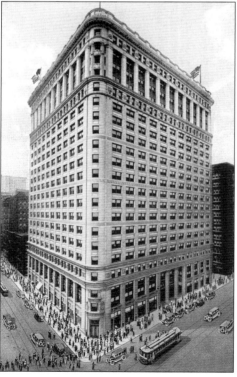

CONWAY BUILDING. Designed by D. H. Burnham and Company, this was the last project of the firm during Burnham's lifetime (completed in 1915; he died in 1912). The building, listed on the National Register of Historic Places, is also known as the Burnham Center. It is now best known as the Chicago Title and Trust Building and is across the street from the city-county building. All four corners of the building are rounded, and the lower colonnade is repeated below its rooftop.

BUILDERS BUILDING. The Builders Building sits at the corner of LaSalle Street and Wacker Drive and faces the Chicago River. The building, like many other Chicago classics, was built by Graham, Anderson, Probst and White (in 1927) and features north-facing Ionic pilasters from the second through fourth floors and a colonnade from the 19th to 21st floors. In 1986, a western addition and a four-story glass penthouse were added. (Courtesy Chicago Photographic Collection [CPC 0-4814], Special Collections Department, University Library, University of Illinois at Chicago.)

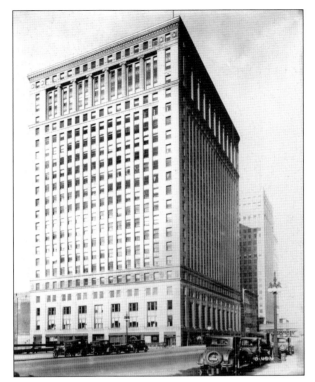

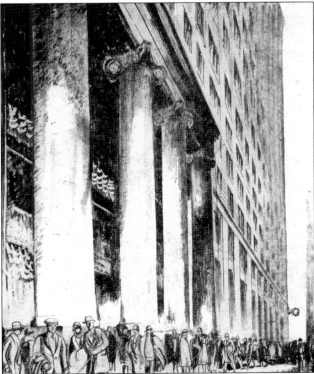

MARSHALL FIELD AND COMPANY. Dating back to 1892, this groundbreaking retail store began as one building and eventually engulfed the entire square block bounded by State, Washington, and Randolph Streets and Wabash Avenue by 1907. (Early expansion projects were a direct result of the influx of shoppers in town for the Columbian Exposition.) The original building and expansion all involved Burnham and the various firms he led.

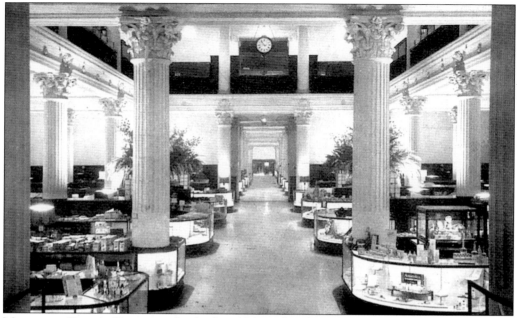

MARSHALL FIELD'S INTERIOR. In the late 19th and early 20th centuries, Marshall Field's was the leading destination for high-class shopping as well as a place for Chicago's elite to see and be seen. The beauty and grandeur of the store's first floor, with its Corinthian columns at the base of the Tiffany atrium, befitted the status of Marshall Field's early clientele. Marshall Field's was the first department store to offer in-store dining and a bridal registry, and its design became a prototype for other stores around the world.

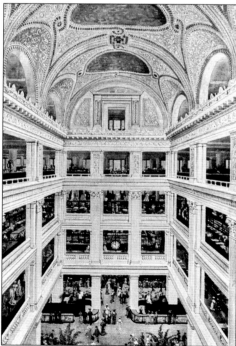

MARSHALL FIELD'S ATRIUM. Inside the store, a five-story Beaux-Arts atrium in the southwest quadrant of the building is topped by a 6,000-square-foot Tiffany vault, designed by Louis Comfort Tiffany himself. The glass structure, added in 1907, is the largest Tiffany mosaic in existence. To the store's north, a 13-story atrium, topped by a skylight and supported by classical columns, spans the height of the building.

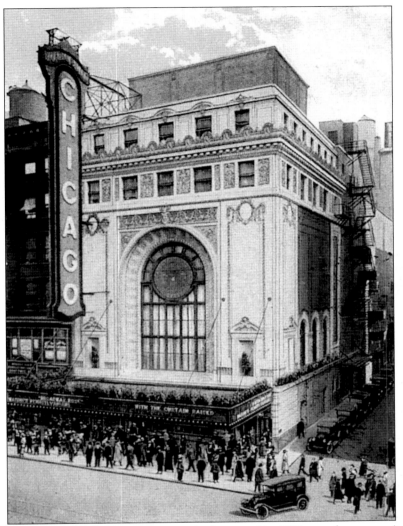

CHICAGO THEATER. The 5,000-seat theater, which opened in 1921, was the country's first movie theater built so extravagantly and became the model for many others. After its opening, *Billboard* called it "perhaps the most magnificent theater in the world" and for decades was Chicago's premier movie palace. By the 1920s, classical architecture had begun to take its inspiration from Louis XIV's grand and ornate Versailles in France, rather than the more stripped-down classicism of Burnham (although Burnham used Paris as a role model for Chicago in his 1909 plan). The Chicago Theater was designed for Balaban and Katz by brothers George and C. W. Rapp, who also designed a number of other majestic theaters throughout Chicago and the rest of the country. The six-story arch on the building's façade is a replica of the Arc de Triomphe in Paris, and the lobby, with its marble columns, glass chandeliers, and red-carpeted stairways, was modeled after Versailles' Royal Chapel. While the theater was built to house the country's new movie industry and was wildly successful for years, by the 1950s its fortune had changed. The city eventually attempted to have the entire downtown theater district declared "blighted" and subject to redevelopment, but the Chicago was saved by preservationists. The theater showed its last movie in 1985 (two years after gaining city landmark status) and, since a 1986 renovation, has hosted concerts, performances, and other special events.

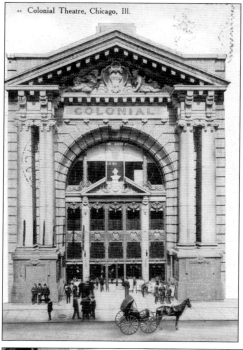

IROQUOIS THEATER. The Iroquois, located at Randolph and State Streets, was built in the Beaux-Arts style of the Parisian Belle Epoch and was advertised as being "absolutely fireproof." However, six weeks after its 1903 opening, during a sold-out performance of *Mr. Bluebeard*, a backstage fire enveloped the building. Approximately 600 people died—more than twice as many as in the Chicago Fire—but the theater was largely undamaged. It reopened as the Colonial Theater in 1905 but was demolished in 1925.

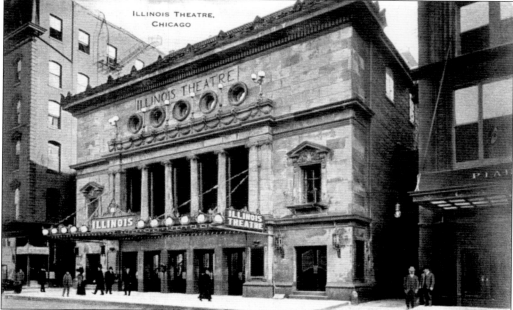

ILLINOIS THEATRE. The 1,249-seat Beaux-Arts theater, which opened in 1900, was a direct descendant of the White City and was located at Jackson Boulevard and Wabash Avenue. Above the entrance of its limestone façade stood a row of Ionic columns flanked by rich aedicular windows, five porthole windows, and a cornice. The Illinois became one of Chicago's best-known legitimate theaters before hosting movies in the 1920s. By the Depression, the theater had closed for good and was turned into a parking lot in 1936.

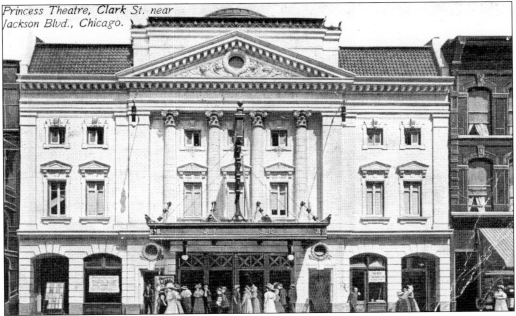

Princess Theatre, Clark St. near Jackson Blvd., Chicago.

PRINCESS THEATRE. Like the Illinois Theatre before it, the Beaux-Arts Princess became one of Chicago's top legitimate theaters in the early 1900s before becoming a movie theater and eventually became a parking lot as well (in 1941). The Princess's façade was made of sparkling white terra cotta, with a row of Composite columns below a pediment, and a red-tile Spanish roof. The 950-seat theater was located at 319 South Clark Street and opened in 1906.

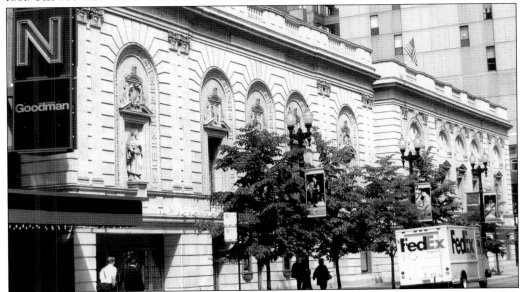

HARRIS AND SELWYN THEATERS. In 1922, these "Twin Theaters" were built on North Dearborn Street in the heart of Chicago's live entertainment district of the early 20th century. Although the interiors of the theaters had fallen into disrepair over the years and were eventually razed, the façades based on French classicism (which are city landmarks) were restored, and since 2000 the building has been the home of the new Goodman Theatre.

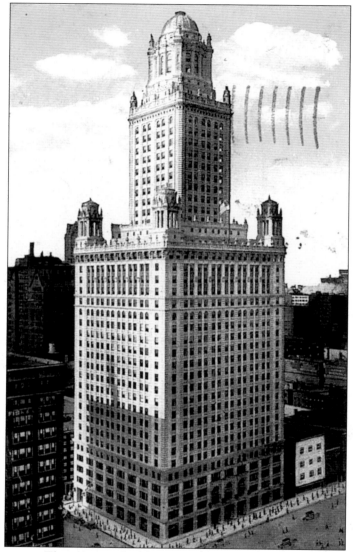

JEWELER'S BUILDING. This 40-story building, at 35 East Wacker Drive, has also been known as the Pure Oil Building and North American Life Building and was built in 1926 by Joachim Giaver and Frederick Dinkelberg, who spent most of their careers working for D. H. Burnham and Company. The intricate Beaux-Arts design is made of terra cotta, and its classical style made the tower one of the best examples of the City Beautiful movement of the early 20th century. The Jeweler's Building was the first office building on Wacker Drive and paved the way for other projects in the Wacker/Wabash corridor, south of the Chicago River but north of other early Loop developments. The building was originally occupied by Chicago's diamond merchants, and in order to reduce the chances of customers being mugged on the street after leaving the building, they drove directly into a central automobile elevator that went as high as the 22nd floor (which gave the Jeweler's Building the distinction as the first office tower in Chicago to have indoor parking). The elevators were eventually discarded, and the indoor parking lots were converted into office space. The building's domed auditorium is now the showroom of Chicago-based architects Murphy/Jahn. The building became a Chicago landmark in 1994.

CIVIC OPERA BUILDING. Built between 1927 and 1929 by Graham, Anderson, Probst and White, the Civic Opera Building (at 20 North Wacker Drive) houses a 3,400-seat auditorium as well as more than 500,000 square feet of office and retail space in its 45 stories. The Art Deco style that had become fashionable by the 1920s provided the decorative elaboration for the classical design of this limestone building. The highlight of the eastern side of the building (the main entrance that faces Wacker Drive) is a colonnaded portico that runs the entire length of the building. Like other Chicago buildings, such as the Merchandise Mart and the former Chicago Daily News building (which faces the opera house and is directly across the river to the west), the Civic Opera building shows the adaptability of classicism and its ability to provide grand public spaces and generally improve the overall character of its area. The building became a city landmark in 1998.

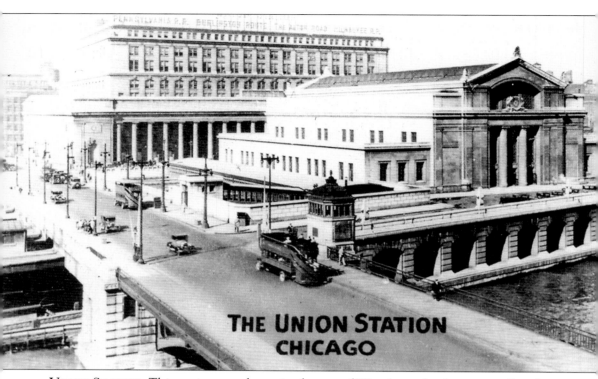

THE UNION STATION
CHICAGO

UNION STATION. This station was the main element of West Loop development in Burnham and Bennett's plan that consolidated passenger railroad facilities to the west of the Chicago River. While Burnham was originally hired to design the building, he died before its completion, and Graham, Anderson, Probst and White took over (construction lasted from 1913 to 1925). The building's concourse (in the foreground) was demolished in 1969, but the remaining aboveground structure, with its stone columns, still stands today. When the complex opened in 1925, Chicago was the center for railroad transportation in the United States, and Union Station was one of approximately a dozen monumental stations built in the "American Renaissance" period, which was similar to the City Beautiful movement and focused on strong urban planning, Beaux-Arts architecture, and adherence to the Greek and Roman models of democracy and law.

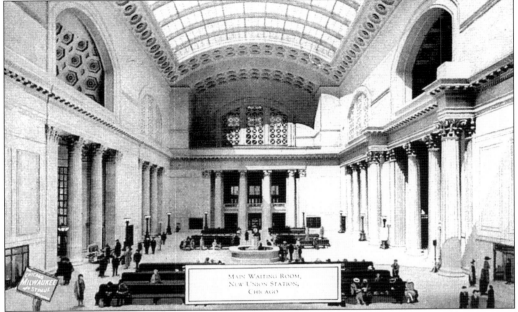

GREAT HALL, UNION STATION. Inside Union Station, its Beaux-Arts "Great Hall" is one of the country's most stately interior public spaces. Union Station is Chicago's Grand Central Station, and the Great Hall is its version of Manhattan's famous main concourse. (After Burnham designed Union Station, he submitted a proposal to design Grand Central but was not selected.) In addition to its classical columns, the Great Hall features a 90-foot vaulted sky-lit ceiling, pink Tennessee marble, and massive wooden benches.

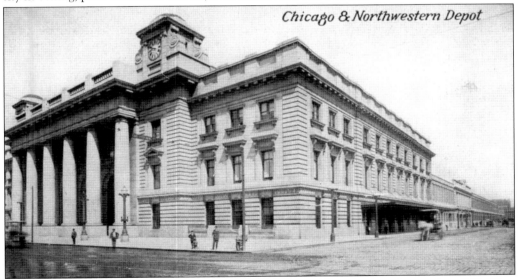

CHICAGO AND NORTHWESTERN RAILWAY STATION. This facility, located at 500 West Madison Street to the west of the Loop, was the Near West Side's most prominent structure when it opened in 1911. The building was a great, substantial Renaissance box enriched with six granite columns that formed an entrance and made a powerful statement about the station's role as the gateway to the Northwest. It also had a grand main waiting room.

CHICAGO HISTORICAL SOCIETY. The Chicago Historical Society (CHS), which became the city's first cultural institution in 1856, moved to its present location at the southwestern edge of Lincoln Park in 1932. The Georgian building, with its Doric portico that leads to an outdoor plaza and faces the park and the Gold Coast, became the society's home when it outgrew its previous location at Ontario and Dearborn Streets. Graham, Anderson, Probst and White designed the building, which has since undergone multiple expansions and renovations in order to keep up with the society's growth. The facility houses a vast collection of Abraham Lincoln artifacts, and the 16th president was named an honorary member of the CHS shortly before his 1860 inauguration. *Standing Lincoln*, erected in 1887, can be seen from the plaza, just to the east.

Five

THE NEAR NORTH

CHICAGO AVENUE EL STATION. Chicago's el system dates back to the late 1800s, and a line reaching Thirty-ninth Street on the South Side was extended into the fairgrounds' Transportation Building in Jackson Park in order to serve Columbian Exposition attendees. The various companies that operated elevated lines throughout the city were unified in 1924, and in 1947, the Chicago Transit Authority (CTA) was formed to take over public oversight of the transportation systems. Today, the CTA's buses and trains reach all corners of the city and 40 suburbs. This 1900 picture shows the Chicago Avenue station (at Chicago Avenue and Franklin Street on the Near North Side) directly beneath the tracks. The station, and many others, were built in a Classical Revival style with a central entrance flanked by arched windows and decorative pilasters. (Courtesy the Chicago Transit Authority.)

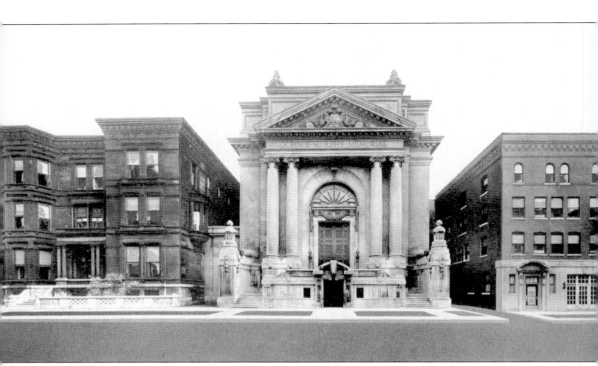

JOHN B. MURPHY MEMORIAL. The American College of Surgeons's (ACS) Murphy Memorial, on East Erie Street, was dedicated in 1926. Named for a local surgeon, it was called "one of the most impressive monumental buildings in the world." Architects Marshall and Fox designed the French Renaissance memorial, based on Paris's Chapelle de Notre-Dame de Consolation. A street-level door is surrounded by curved stairways that lead to a central porch and bronze doors with sculpted panels that list important historical names in medicine, such as Aesculapius, the Greek god of medicine. The memorial, which was built with an auditorium, library, museum, laboratories, and classrooms, is flanked by two other buildings that were also used as ACS offices. In 2005, the building was renovated to be used for special functions of the ACS. (Courtesy American College of Surgeons.)

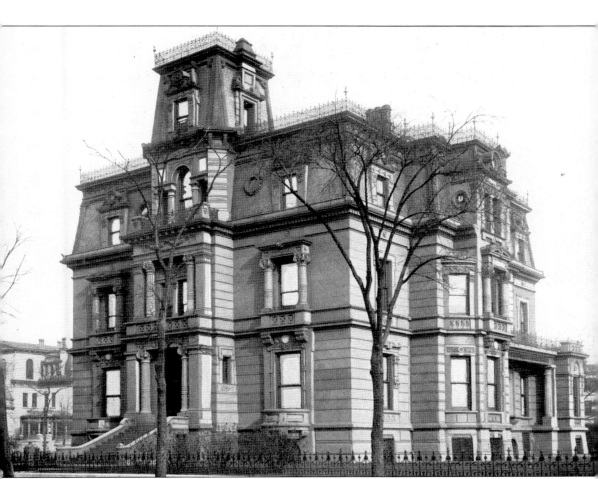

McCormick Mansion. Formerly located at 675 North Rush Street, the mansion was the home of Cyrus McCormick, the inventor of the mechanical reaper and later the editor of the *Chicago Tribune*. While McCormick's invention directly led to the rise of the urban labor force, his Chicago factory was the site of the infamous Haymarket Square Riots in 1884, which started when his employees organized to improve their working conditions. His 35-room home (shown here in 1893) was built from 1875 to 1879 and designed in the French Second Empire style by Cudell and Blumenthal. It was demolished in 1954. The Second Empire style was highly popular in the late 1800s (starting before the fair) and originated in Napoleon III's Paris. It featured elaborate enrichment of windows, doors, rooflines, and corners and often used classical columns, pilasters, arches, pediments, and balustrades. The McCormick mansion incorporated many of these classical elements, as well as the Second Empire's trademark mansard roof, whose name acknowledges François Mansart, the French architect whose designs sparked renewed interest in the style in the 17th century and were used extensively during Napoleon's rebuilding of Paris in the mid-19th century. (Courtesy Chicago Public Library, Special Collections and Preservation Division.)

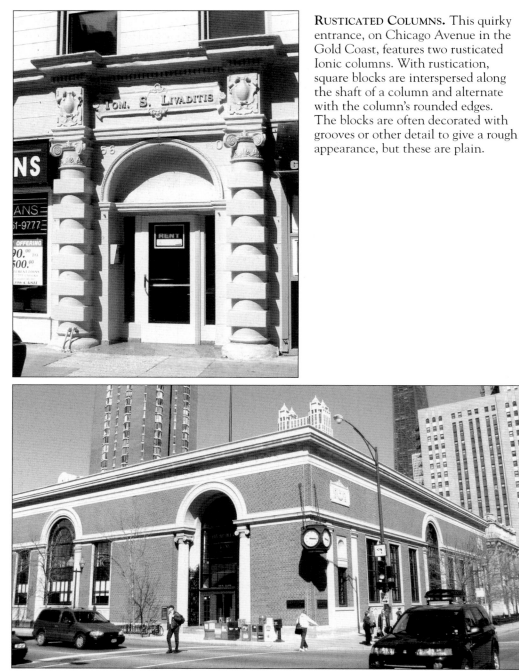

RUSTICATED COLUMNS. This quirky entrance, on Chicago Avenue in the Gold Coast, features two rusticated Ionic columns. With rustication, square blocks are interspersed along the shaft of a column and alternate with the column's rounded edges. The blocks are often decorated with grooves or other detail to give a rough appearance, but these are plain.

COSMOPOLITAN NATIONAL BANK. This unassuming bank at Clark and Division Streets was designed by Schmidt, Garden and Martin in 1920. The main entrance of the red-brick building (on Clark Street) is flanked by two Ionic columns, with pilasters surrounding arched windows on the sides and a cornice that runs the length of the roofline. Richard Schmidt was one of Chicago's most prolific architects and designed more than 300 hospitals, including Michael Reese on the South Side.

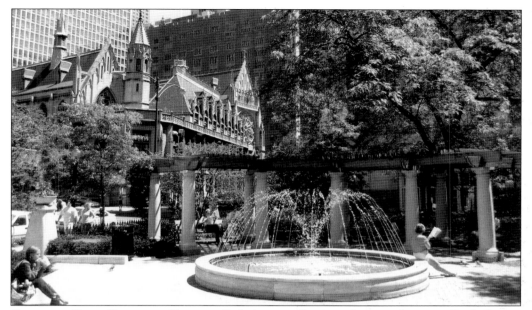

CONNORS PARK PERGOLA. Connors Park is a small triangular area between Rush Street, Wabash Avenue, Delaware Place, and Chestnut Street in the Gold Coast, and the pergola (a garden feature supported by columns) is at its southern end. The city purchased this small slice of land from a subdivider in 1848 and transferred it to the Chicago Park District in 1959. The park is named for William J. Connors (1891–1961), a local politician who served seven terms in the state senate.

SCHOLL COLLEGE OF PODIATRIC MEDICINE. The building, at Oak and Dearborn Street in the Gold Coast, was originally built as a YMCA in 1928 and later used by the school. Facing Oak Street was a classically inspired Art Deco entrance with capitals based on those of Athens's Tower of the Winds, which was a popular inspiration because it was simple but elegant. Despite efforts by preservationists, the building was demolished in 2005.

ANNUNCIATION CATHEDRAL. This Greek Orthodox church is located on LaSalle Street in Chicago's Gold Coast. Its classical details include four Corinthian columns supporting the arched entranceway, topped by a simple pediment, as well as arched windows throughout and a balustrade atop the twin steeples. Architect N. A. Dokas, a Greek Chicagoan, designed the church in 1910.

ASTOR STREET HISTORIC DISTRICT. A four-block stretch of Astor Street in the Gold Coast, between Division Street and North Avenue, became a city landmark in 1975. The homes on the street, primarily built between 1880 and 1940, are in a wide variety of historical revival styles, including classical. These Corinthian columns guard the entrance of a red-brick mansion (which is now a condominium building) built by Holabird and Roche in 1897 at Astor and Division Streets.

86

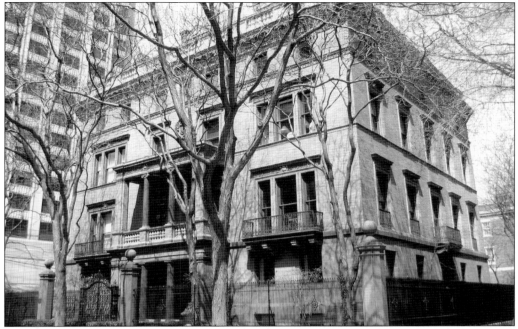

PATTERSON-McCORMICK MANSION. This Gold Coast mansion at 1500 North Astor Street was built by Stanford White of McKim, Mead and White in 1891. White and his firm were leading Beaux-Arts architects (and significant contributors to the Columbian Exposition), and White built this home as a colorful and inventive adaptation of an Italian palazzo with a cubic block, symmetrical façade, and a classical cornice, balustrade, and prostyle porticos. The building now contains nine luxury condominiums.

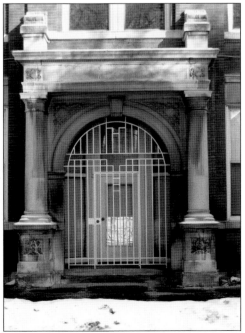

COBBLER SQUARE. Now a residential and retail complex on Wells Street in Old Town, the complex consists of approximately 20 buildings that have been pieced together, including the former Western Wheel Works bicycle plant. The earliest building in the complex dates to 1880, and Dr. Scholl manufactured his foot-care products on the site for much of the 20th century. This classical entrance, facing south on Evergreen Avenue, is the only surviving one; an identical one on the north side at Schiller Street has been replaced.

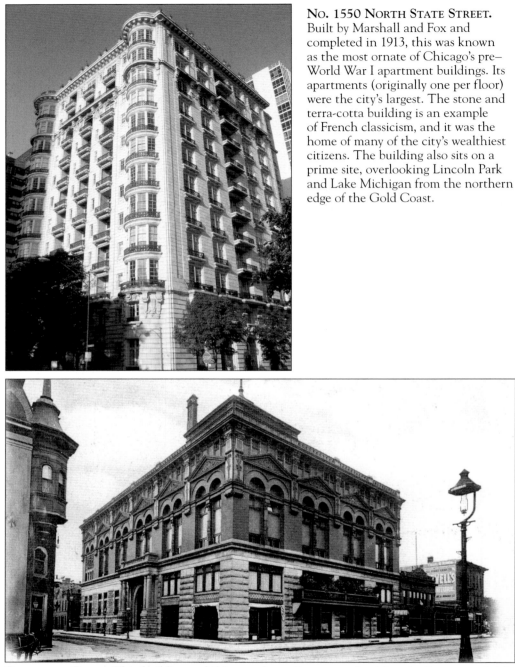

NO. 1550 NORTH STATE STREET. Built by Marshall and Fox and completed in 1913, this was known as the most ornate of Chicago's pre–World War I apartment buildings. Its apartments (originally one per floor) were the city's largest. The stone and terra-cotta building is an example of French classicism, and it was the home of many of the city's wealthiest citizens. The building also sits on a prime site, overlooking Lincoln Park and Lake Michigan from the northern edge of the Gold Coast.

GERMANIA CLUB. This building exhibits northern European classicism in limestone, brick, and terra cotta, emphasizing rugged forms rather than the more graceful forms of France and Italy popularized by the Columbian Exposition. The Gold Coast building was built in 1888 and was added to the National Register of Historic Places in 1976. It housed a private social club until the 1980s but is now a popular special events venue. A stained-glass window inside the building was displayed at the 1893 fair.

SEDGWICK STREET EL STATION. This station (shown in 1973), at Sedgwick Street and North Avenue in Old Town, opened in 1900 and is a replica of the Chicago Avenue station. The structure is made of brick, with terra-cotta trim, and has an Italian Renaissance look. William Gibb designed the station, which like the Chicago Avenue station, is still in use and has been largely unaltered in the last 100-plus years. (Courtesy the Chicago Transit Authority.)

CRILLY COURT. Located within the historic Old Town Triangle District, the one-block-long street features apartment buildings on the east side and houses on the west side, dating to the late 1800s. Daniel Crilly, the street's developer, built classically inspired entrances on the four apartment buildings that show the names of his four children (Edgar, Isabelle, Oliver, and Erminnie). Both ends of the street are marked by large piers. While working at nearby Second City, Bill Murray and John Candy lived in Crilly apartments.

ALTA VISTA TERRACE DISTRICT. The 3800 block of North Alta Vista Terrace (between Byron and Grace Streets) is likely the most unique street in Chicago. Built between 1900 and 1904 by developer Samuel Eberly Gross and architect J. C. Brompton, the block consists of 40 homes (20 on each side), and each of 20 different façades on one side of the street is duplicated on the other side, but starting on the opposite end. The home shown here, with its pedimented doorway and roof and aedicular windows, is at 3814 on the west side of the street; its twin is across the street and just north. Gross decided to build Alta Vista Terrace after a trip to London, during which he was inspired by its neighborhoods and row houses. The two middle homes on each side of the street are three stories high; all others are two stories, and both types of homes have an identical floor plan. While the block displays a wide range of architectural styles, the use of classicism is frequent. According to its National Register of Historic Places nomination form, "Details of many of the row houses reflect the Classical Renaissance in American architecture that grew out of the 1893 World's Columbian Exposition. Columns, pediments, and pilasters characterize several of the façades." The submission, which was accepted in 1972, also described Alta Vista Terrace as "a street out of the past, a block-long microcosm of turn-of-the-century charm and dignity and architectural eclecticism." In 1971, the district also became a Chicago landmark.

Six

THE NORTH SIDE

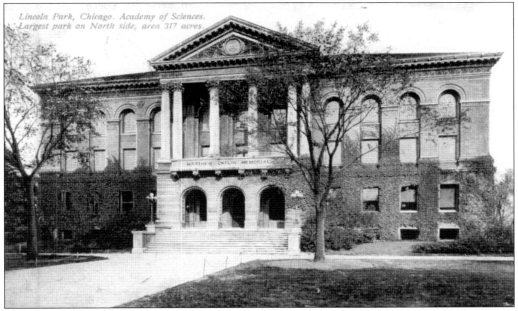

MATTHEW LAFLIN MEMORIAL BUILDING. The building, located in Lincoln Park, was originally the home of the Chicago Academy of Sciences (CAS) and now houses the Lincoln Park Zoo's offices. In 1893, the facility replaced the original CAS building, which was destroyed in the 1871 fire and, until 1995, displayed the academy's collections and exhibits. The building's Corinthian temple front and triple-arched entrance is flanked by wings featuring blind arcades. The building was a gift from Matthew Laflin, a prominent 19th-century developer.

ST. HEDWIG CHURCH. Construction began in 1894 for the church at Webster and Hoyne Avenues as a replacement of the original church that was overcrowded but had opened just six years earlier. St. Hedwig was the last of Chicagoan Adolphus Druiding's many church designs across the country. Above the tetrastyle Tuscan entrance is a second colonnade, with a similar design repeated on the aedicular windows to the sides and incorporated into both steeples.

LINCOLN PARK HIGH SCHOOL. The school, located in the heart of Lincoln Park, was built around the beginning of the 20th century along with other public facilities for the growing North Side population, which moved to the previously undeveloped area during Chicago's post-fire rebuilding. The grand scale of the Beaux-Arts building indicates the important civic role of education, an idea directly inspired by the Columbian Exposition. The school was first named for Robert Waller, a vice president of the fair's board.

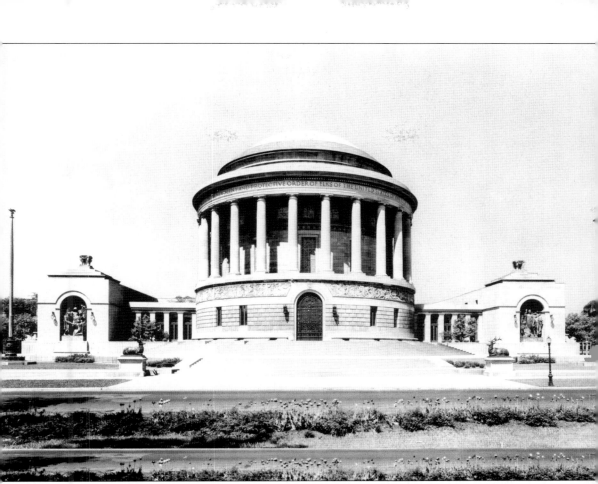

ELKS NATIONAL MEMORIAL. The Doric, 100-foot rotunda was dedicated in 1926 and designed by New York architect Edgerton Swarthout. The project was originally dedicated to Elks who were killed in World War I. It was rededicated in 1946 to honor World War II vets and on July 4, 1976, for veterans of Korea and Vietnam. The niche in the north wing (to the right) depicts a figure of Columbia holding a torch of liberty above a family, and the southern niche depicts Mother Nature with three stages of a man—in his youth, prime, and old age. The rotunda's marble interior features various murals, art-glass windows, and bronze sculptures. The marble was quarried in a number of countries around the world, including the United States, Greece, Italy, Austria, and France. The monument is located at Diversey Parkway and Lakeview Avenue, just west of Lake Michigan and Lincoln Park.

DIVERSEY THEATRE. Located just north of Clark Street and Diversey Parkway, the former 2,000-seat Diversey Theatre opened in 1924. The terra-cotta façade was designed in a Spanish Baroque style (an exuberant form of classicism) by Levy and Klein's Edward Eichenbaum. In the 1930s, the theater was renamed the Century in honor of Chicago's 1933–1934 Century of Progress World's Fair, and in 1973, the theater closed. The building is now the Century Shopping Centre and includes a seven-screen art house movie theater. (Courtesy Chicago Public Library, Special Collections and Preservation Division.)

THEURER-WRIGLEY HOUSE. Located at 2466 North Lakeview Avenue, this home was designed in 1896 by Richard Schmidt for brewer Joseph Theurer, who later sold it to the Wrigley family. Built in orange brick and terra cotta, the house's bays, quoins, decorative windows, cornice, and Ionic porch provide a classical look with a German flair. The 20,000-square-foot, single-family home is a Chicago landmark and also part of the Arlington and Roslyn Place Historic District. It was for sale in 2005 for $11 million.

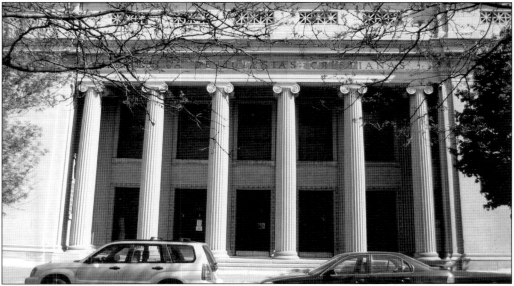

ELEVENTH CHURCH OF CHRIST, SCIENTIST. This former Christian Science church, at 2840 North Logan Boulevard, was designed by Leon Stanhope (who also designed Chicago's Eighth Church) in 1916 and is on the National Register of Historic Places. For the last 20-plus years, the building has been home of the Templo Monte Hermon but, in 2005, was for sale. The temple front has a hexastyle Ionic portico, and the building's interior is in near original condition.

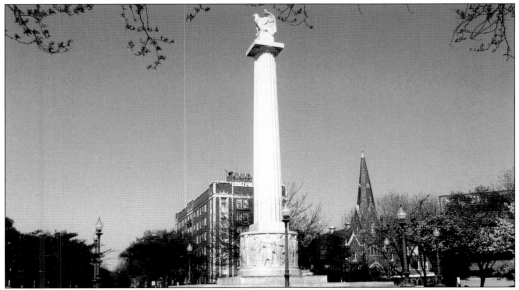

ILLINOIS CENTENNIAL MONUMENT. Located in Logan Square and surrounded by the hub of Kedzie Avenue, Milwaukee Avenue, and Logan Boulevard, the monument commemorates Illinois's 100th anniversary of statehood and was dedicated in 1918. Its architect was Henry Bacon, who also designed Washington's Lincoln Memorial. The Doric column is made of Tennessee pink marble and is topped by an eagle. It was based on the proportions of the Parthenon's columns in order to symbolize the connection between the democracies of Greece and the United States.

CITIZENS STATE BANK OF CHICAGO. This view shows the bank in 1929, at 3328 North Lincoln Avenue. Reminiscent of the square Lake Shore Trust and Savings Bank on Michigan Avenue, the rectangular building had full-height pilasters and columns. Although the bank was located well outside of the Loop, many other Chicago banks were similarly classically designed. (Courtesy Chicago Public Library, Special Collections and Preservation Division.)

BRUNDAGE BUILDING. Located at 3325 North Lincoln Avenue, the building is named for Avery Brundage, the building's contractor and the longtime head of the International Olympic Committee. The terra-cotta flatiron building (in order to fit the unusual intersection at Lincoln and Marshfield Avenues) was designed by William Uffendell in 1923 and is lined by four-foot-wide Ionic pilasters that shelter tall arches and paired windows.

NORTHSIDE AUDITORIUM BUILDING. Originally opening as the Swedish Community Center in 1927, the building has been home to the legendary 1,100-seat Metro since 1982. Since an opening concert with a young band named R.E.M., performers ranging from James Brown to Pearl Jam have played the Metro. This picture was taken on April 1, 1990, the day of an early Nirvana concert. The building's ornate façade has clear classical references, such as the richly detailed Ionic pilasters. (Courtesy Chicago Public Library, Special Collections and Preservation Division.)

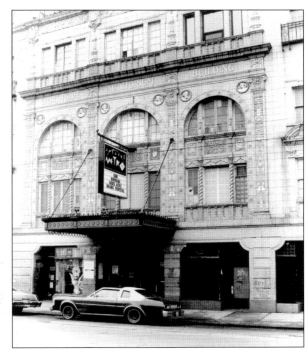

ADDISON STREET EL STATION. The original Addison Street station, along with the Chicago Avenue and Sedgwick Street stations (as well as those at Fullerton Parkway and Armitage Avenue), was part of the original Northwestern Elevated line and had the standard William Gibb design for a Northwestern ground-level station. Located at Addison Street and Sheffield Avenue, the station (shown in 1988) was demolished in 1994 and replaced with a less distinctive structure. (Courtesy the Chicago Transit Authority.)

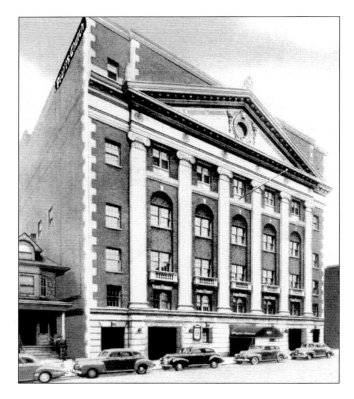

PEOPLES CHURCH OF CHICAGO. Designed in 1925 by architect John Pridmore, a North Side resident who was born in England and specialized in theaters and churches, the building's façade has a superimposed temple front. The church is one of many Pridmore designs on the far North Side and is located on the 900 block of West Lawrence Avenue in Uptown.

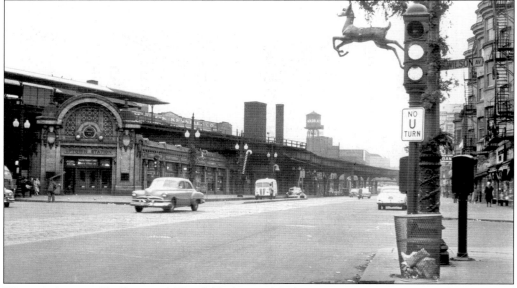

WILSON AVENUE EL STATION. The Gibb-designed Wilson Avenue station, at Broadway, opened in 1900 as the terminus of the Northwestern line. The original Beaux-Arts entrance, seen at the left of the photograph as it appeared in 1955, was removed in 1959, when the station was renovated. However, the station is listed on the National Register of Historic Places as a contributing structure in the Uptown Square Historic District. (Courtesy the Chicago Transit Authority.)

WILLIAM P. GRAY PUBLIC SCHOOL. Located at Warwick and Laramie Avenues in Portage Park, this Ionic structure has a simple pediment protecting a recessed entrance. The school was designed by Arthur Hussander, the prolific board of education architect who designed many other classical schools throughout Chicago.

OLD MAIN BUILDING. This 1895 photograph shows the faculty of North Park College in front of the Old Main building, near Foster and Spaulding Avenues. The Georgian Revival structure was the campus's first building, in 1894, after the college relocated from Minneapolis. (Courtesy Chicago Public Library, Special Collections and Preservation Division.)

SWEDISH AMERICAN STATE BANK. Originally built as a bank at 5400 North Clark Street in Andersonville, the building is now residential and commercial. The terra-cotta exterior exhibits the exuberance of Paris's Belle Epoch and creatively departs from typical classical forms. The bank was designed in 1913 by Ottenheimer, Stern and Reichert.

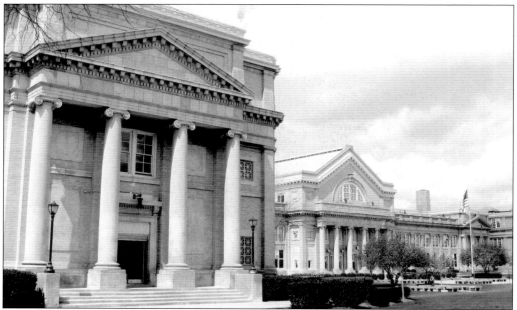

SENN HIGH SCHOOL. Located on the 5800 block of North Glenwood Avenue in Edgewater, Senn is another monument to the civic importance of education and presents a virtual catalogue of classical elements. Senn opened in 1913 and was named after Dr. Nicholas Senn (1844–1908), a groundbreaking local surgeon.

ST. IGNATIUS CHURCH. The church, on Glenwood Avenue in Rogers Park, was designed in 1916 and 1917 by Henry Schlacks, a Chicagoan known for his church designs. The building's hexastyle Composite portico is topped by a rarely seen segmental pediment. A single steeple is at the church's southeast corner.

SIXTEENTH CHURCH OF CHRIST, SCIENTIST. Now known as the St. George Cathedral, the church was originally built as one of Chicago's many classical Christian Science churches. This severely classical church, on Touhy Avenue in Rogers Park, was built in 1922 by Howard Cheney, a Chicagoan who was one of the leading church architects of the early 20th century and who designed a number of other churches for Christian Scientists.

GARFIELD PARK STATE SAVINGS BANK. This was one of numerous banks in Chicago built in the classical style, including the lineup of banks on LaSalle Street in the Loop. Banks of the past "resembled Greek or Roman temples," as the *Chicago Tribune*'s architectural critic Blair Kamin wrote in 2005, and "inspired awe." However, under the headline "Once Grand, Now Bland," he wrote that modern bank design has become "disappointingly faceless" and that "now banks want to look like Starbucks, not the Parthenon." (Courtesy Chicago Public Library, Special Collections and Preservation Division.)

Seven

THE WEST SIDE

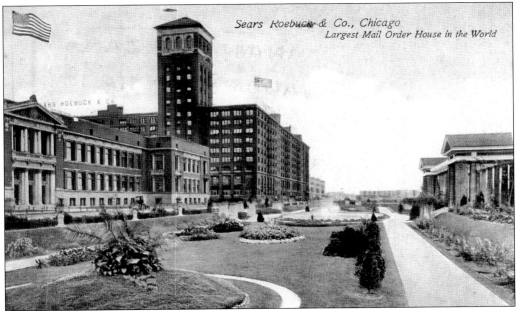

SEARS, ROEBUCK AND COMPANY ADMINISTRATION BUILDING. The classical Administration Building (left) was the company's headquarters for more than 60 years beginning in 1905 and was next to the original Sears Tower. Across from the Administration Building is a classically inspired pergola and garden, which showed the importance of landscapes in classical architecture and recalls Olmsted's grounds at the Columbian Exposition. The former North Lawndale campus, including the Administration Building, has been converted into residential, commercial, and office space and became a Chicago landmark in 2002.

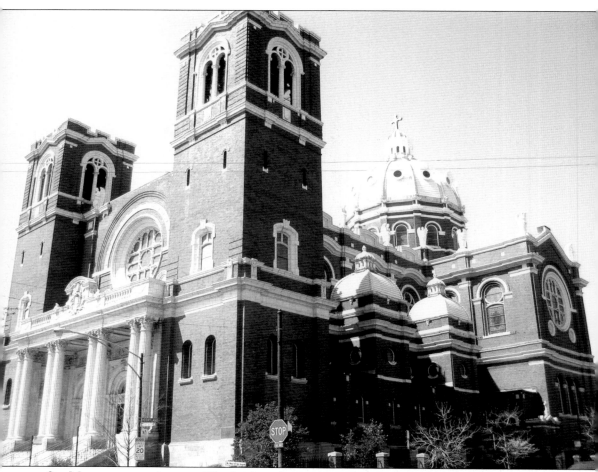

ST. MARY OF THE ANGELS. The brick and terra-cotta church, designed by Harry J. Schlacks, opened in 1920 to serve the growing Polish population that had settled on the northwest side of the city. However, while the church now receives great exposure aside the Kennedy Expressway, the construction of the highway (specifically the section from Lake Street to Foster Avenue that opened in 1960) caused many nearby homes to be razed, which led to a significant decrease in the church's membership. The building's design, with towers flanking a projecting porch with four pairs of Corinthian columns and a ribbed dome rising to a lantern, is meant to evoke St. Peter's Basilica in Rome and has been recognized as one of the best examples of Roman Renaissance architecture in the country. The church was scheduled to be demolished in 1988 because of its poor condition but was saved with restorations that took place through 1997, including repairs to the dome, stained-glass windows, and all 26 roof angels.

NOEL STATE BANK BUILDING.
In the lower right-hand corner of the historic photograph to the right is the Noel State Bank building, at the now popular intersection of North, Damen, and Milwaukee Avenues. The building is listed on the National Register of Historic Places and was designed in 1919 by architect Gardner Coughlen. Today, as seen below, the frieze above the irregular-shaped building's Corinthian pilasters has been replaced with the name of the building's current tenant, the Midwest Bank and Trust Company. (Right, courtesy Chicago Photographic Collection [CPC 32-3505-4], Special Collections Department, University Library, University of Illinois at Chicago.)

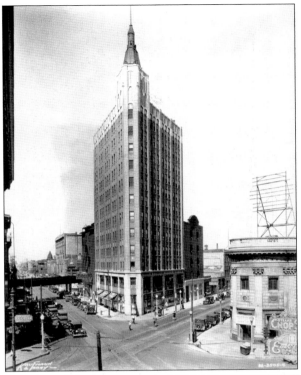

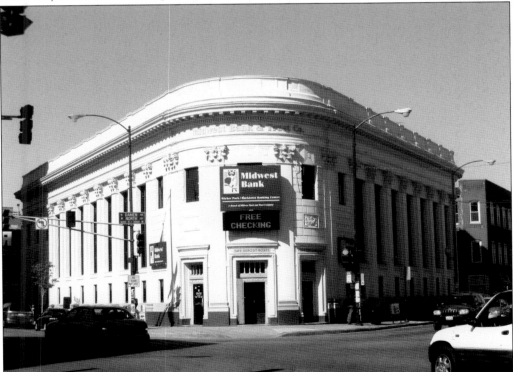

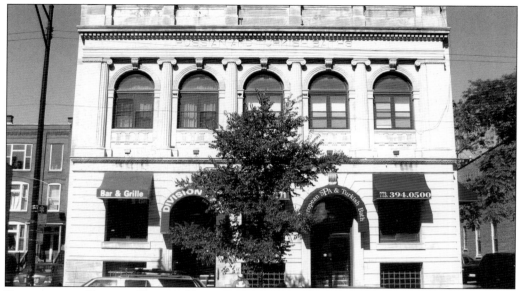

RUSSIAN AND TURKISH BATHS. Chicago's only Russian bathhouse has hosted local tough guys Jesse Jackson, Mike Ditka, John Belushi, and reportedly John Dillinger. The Renaissance Revival building, built in 1907, was described in Chicagoan Saul Bellow's *Humboldt's Gift* as follows: "In the super-heated subcellars these Slavonic cavemen and wood demons with hanging laps of fat and legs of stone and lichen boil themselves and splash water on their heads by the bucket."

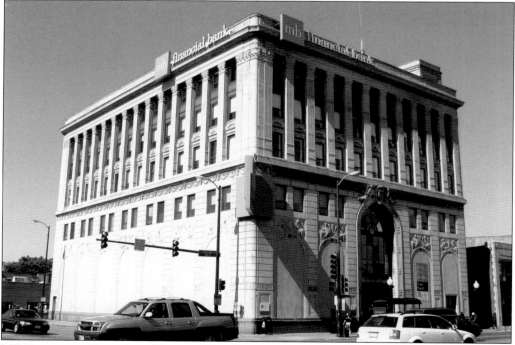

MB FINANCIAL BUILDING. This stately rectangular bank was built in 1929 by Adler and Adler at the corner of Ashland Avenue and Division Street in West Town. The upper floors, with Corinthian piers supporting a subdued cornice, have held MB Financial offices since 1934.

CHOPIN PUBLIC SCHOOL. This school, named after composer Frédéric Chopin, opened in 1917 in West Town. The southern façade of the building features four colossal Ionic columns that front a recessed entrance, surrounded by a labyrinthine fret design. Chicago Board of Education architect Arthur Hussander designed Chopin, as well as other public schools throughout the city in a more elaborate Beaux-Arts style.

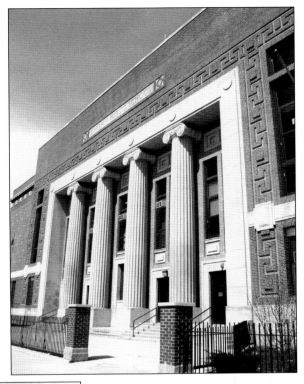

HOLY TRINITY CHURCH. This Renaissance Revival church was built in 1905 on Noble Street, just south of Division Street, in West Town and still stands today, although in 2005, its steeples were being rebuilt. Its Corinthian temple front embraced by elaborate twin towers recalls the central European Baroque classicism of the members' homelands. The church was designed by William Krieg and has historically served the local Polish population.

LEGLER BRANCH LIBRARY. The Legler branch is located in Garfield Park, and was built in 1920 by Alfred Alschuler. The building is on the National Register of Historic Places and is named for Henry Legler, who established Chicago's regional library system. The library's symmetrical design uses elegant forms introduced by Robert Adams, the 18th-century British architect, and draws on the Tower of the Winds in ancient Athens for its capitals. The building has been completely renovated and restored. It reopened to the public in late 1993. (Courtesy Chicago Public Library, Special Collections and Preservation Division.)

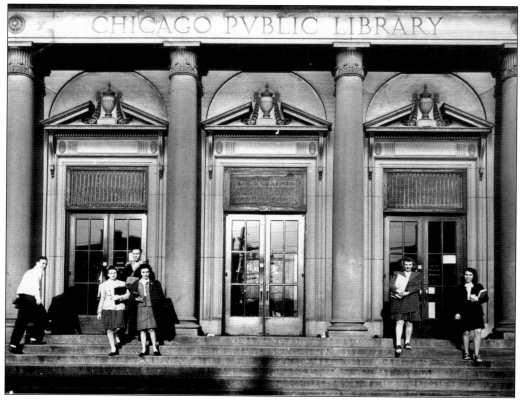

AUSTIN BRANCH LIBRARY. The "Friends of Austin" stand in front of the library's main entrance. One of many classical public libraries in Chicago, the branch was built on the West Side in 1929. Like the Legler library, it illustrates how ancient classicism can be combined with the more modern Art Deco design, which became popular in the 1920s and 1930s. (Courtesy Chicago Public Library, Special Collections and Preservation Division.)

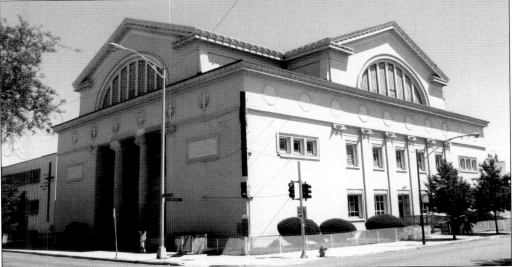

METROPOLITAN MISSIONARY BAPTIST CHURCH. The church was originally built as a Christian Science church in 1901 by Hugh M. G. Garden. Garden's design uses traditional forms, such as a semicircular window in the broken pediments and paired columns before the recessed porch. But with other elements, such as his capitals, Garden shows his experience with architects Sullivan, Wright, and others involved with the Chicago school of architecture. The church, on West Washington Boulevard, became a Chicago landmark in 1989.

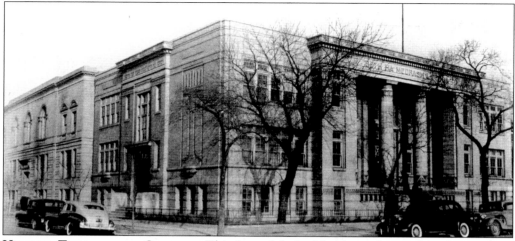

HEBREW THEOLOGICAL COLLEGE. This Lawndale building was designed by Loewenberg and Loewenberg and was dedicated in 1922. The architects used a collection of elements taken from central Europe's interpretation of classicism in the early 19th century. The college occupied the building until 1956, and the Lawndale Community Academy was a recent tenant, but the building is now vacant and boarded up. (Courtesy Hebrew Theological College.)

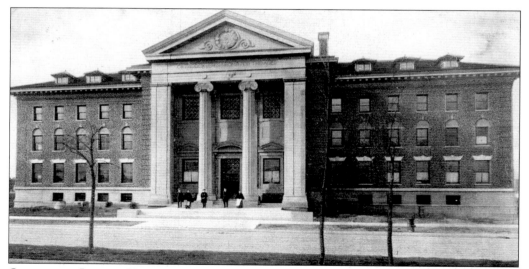

ORTHODOX JEWISH HOME FOR THE AGED. In the early 20th century, Chicago's Jewish population, which first settled near Maxwell Street, moved south and west, and primarily to Lawndale on the West Side. As a result, many Jewish institutions were built in the neighborhood, including the Home for the Aged and the Hebrew Theological Academy. This building's portico was built on a monumental scale, with two colossal Ionic columns topped by a pediment that reached high above the roofline.

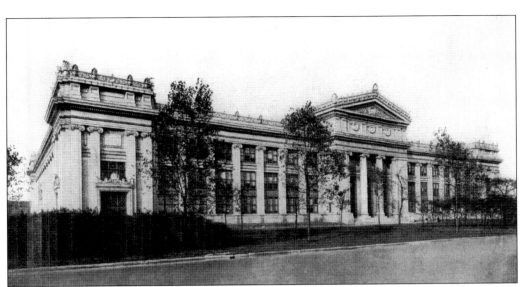

HARRISON HIGH SCHOOL. Built in 1912 in South Lawndale, the building was originally Harrison Technical High School but is now Saucedo Academy, a K–8 elementary school. The Beaux-Arts building, designed by Chicago Board of Education architect Arthur Hussander, would have fit in perfectly in the White City, and its main entrance is similar to the southern portico of the Museum of Science and Industry. (Courtesy Essex Antiques.)

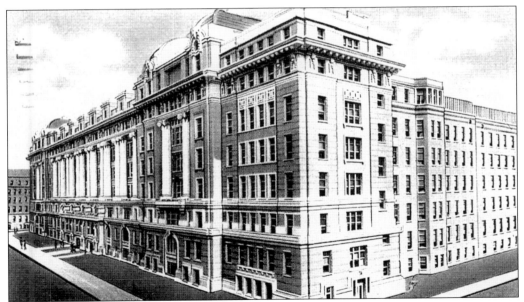

COOK COUNTY HOSPITAL. The Beaux-Arts hospital, built in 1913, was called Chicago's Statue of Liberty because it provided services regardless of people's ability to pay. County gained popular fame as the home of *ER* but really made its mark with the world's first blood bank (in 1937) and Chicago's first HIV/AIDS clinic (1983). The hospital has been empty since 2002, when a replacement facility opened, but preservationists are fighting to save the building and its dramatically scaled, impressively composed Ionic façade.

ST. ADALBERT'S CHURCH. The St. Adalbert parish (one of the city's first Polish parishes) dates to 1874 in Chicago, but the current church on West Seventeenth Street was dedicated in 1914. It is one of many church designs by Henry Schlacks, who based the church on Rome's St. Paul's Basilica. Schlacks placed eight polished granite Corinthian columns at the church's entrance and added twin towers with copper cupolas that rise 185 feet above ground level and would have been familiar to central Europeans.

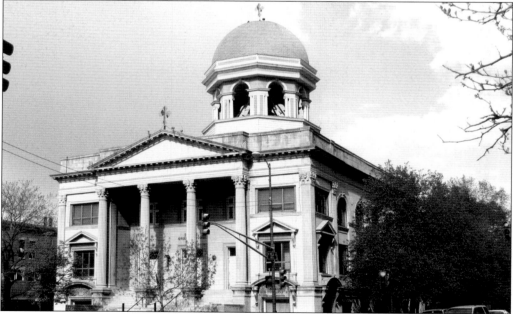

TEMPLE ANSHE SHOLOM. The Greek Revival building served as a synagogue from 1910 through 1927, when it became St. Basil, a Greek Orthodox church. A Hebrew inscription is still visible on the frieze above the Corinthian portico. The building is located at Ashland Avenue and Polk Street and was designed by Alexander Levy, who also built a number of Chicago's early theaters.

COOK COUNTY CRIMINAL COURT BLDG.

COOK COUNTY CRIMINAL COURTHOUSE AND JAIL. This imposing-looking classical building at Twenty-sixth Street and California Avenue opened in 1929 and was designed by Hall, Lawrence and Ratcliffe. Above the Doric columns on the façade are allegorical figures that symbolize Law, Justice, Liberty, Truth, Might, Love, Wisdom, and Peace. Under the adjacent panels, topped by carved eagles, is inscribed "S.P.Q.C.," Chicago's adopted version of S.P.Q.R., which translates as "the Senate and People of Rome." S.P.Q.R. was the official name of the Roman Republic and Empire, and the acronym appears on manhole covers, the city's coat of arms, and public buildings in Rome to this day. When the jail opened, it was thought to house the largest concentration of prisoners in the free world and eventually counted Al Capone and John Wayne Gacy among its "guests." In the summer of 1971, B. B. King recorded his classic *Live in Cook County Jail* album in front of 2,000 inmates inside the building. (Courtesy Chicago Photographic Collection [CPC 29-1973-10], Special Collections Department, University Library, University of Illinois at Chicago.)

FIRST CHURCH OF CHRIST, SCIENTIST. This church became the model for Christian Science churches across the country, and as a result, the organization led a prolonged classical building movement. Solon Beman, who was on the 10-member Board of Architects for the Columbian Exposition, designed the church in the style of the fair's Merchant Tailors' building, which he also designed. In November 1897, nearly 10,000 Christian Scientists came to Chicago for the dedication of the building, which was described in the Chicago *Times-Herald* as being "very near to realizing the ideal of a place of worship . . . certainly surpassed in beauty and qualities of utility by few if any churches in the West." Beman went on to design at least a dozen other Christian Science churches across the country, as well as Chicago's Blackstone Memorial Branch Library. The church, on the 4000 block of South Drexel Boulevard, now houses the Grant Memorial AME Church.

Eight

THE SOUTH SIDE

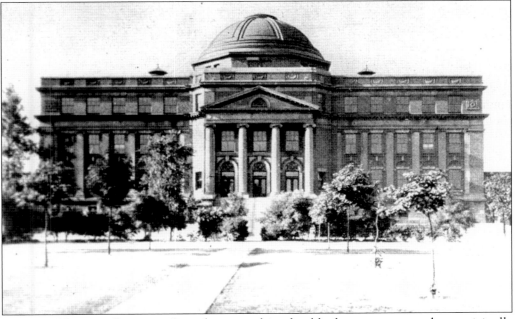

CHICAGO NORMAL COLLEGE. Over the years, this school had many names and was originally known as the Cook County Normal School, which was the first teacher-training institution in Illinois. The building, in Englewood, was highlighted by its Ionic portico at the main entrance and a dome that was centered on a symmetrical plan. The college became part of Chicago State University, but the state's teaching college is now Northeastern Illinois University on the far North Side of Chicago. (Courtesy Chicago Public Library, Special Collections and Preservation Division.)

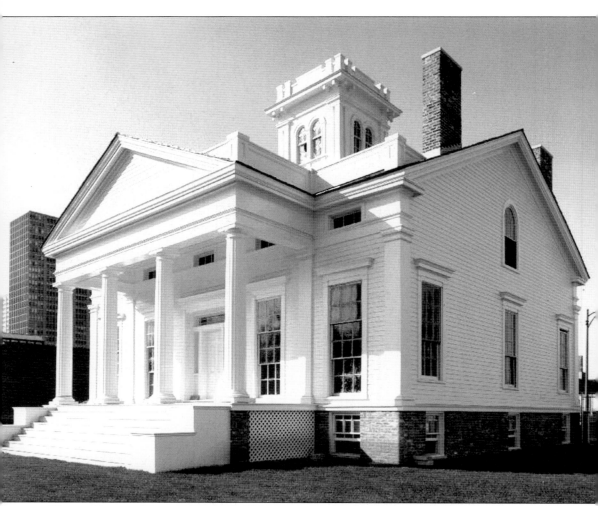

HENRY CLARKE HOUSE. Dating back to 1836, the Clarke House is not only Chicago's oldest surviving building (and a year older than the city itself), but it is one of the few remaining examples of true Greek Revival architecture in the city. Greek Revival was popular in the early 1800s and was seen as a way to bring order and stability to a young and rough country through architecture. The house is visually dominated by its simple Doric portico and pediment, and the unusual cupola was added atop the building in the 1850s. The home of Henry and Caroline Clarke and their children was originally built at Sixteenth Street and Michigan Avenue but was moved to Forty-fifth Street and Wabash Avenue in 1872, when Clarke's children sold the house. In 1977, the city purchased the house and moved it to its present location at Eighteenth Street and Indiana Avenue in the landmark Prairie Avenue District, not far from its original location. Extensive restoration, including a new foundation and repair of the interior that was damaged in a fire, is returning the home to its 1850s condition. The house is now a museum and is operated and maintained by Chicago's Department of Cultural Affairs. (Courtesy Robert Stall and the City of Chicago Department of Planning, Landmarks Division.)

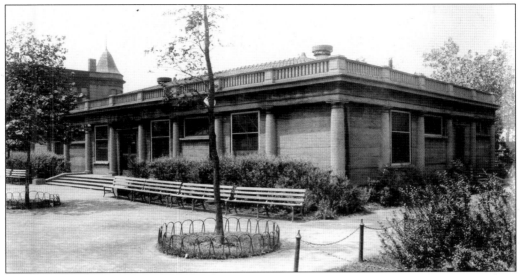

HARDIN SQUARE BRANCH LIBRARY. The Hardin Square branch no longer exists but was located at Wentworth Avenue and Twenty-sixth Street. The actual library was within a city park's fieldhouse, and the benches and wide walkways were built so library patrons could enjoy both the library and the park simultaneously. Tuscan columns ring the building; the Tuscan order is the most basic and was added by the Romans to the three original Greek orders (Doric, Ionic, and Corinthian). (Courtesy Chicago Public Library, Special Collections and Preservation Division.)

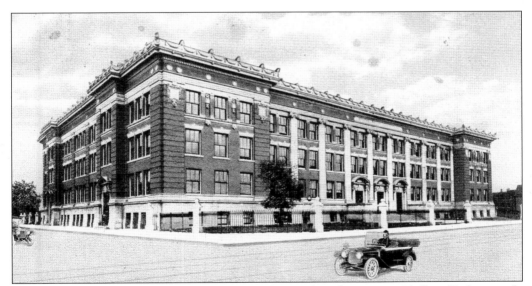

WENDELL PHILLIPS HIGH SCHOOL. Built on the South Side in 1904, Phillips High recently celebrated its centennial, and the building became a Chicago landmark in 2003. While Phillips started out with mostly white, wealthy students (such as Armours, Pullmans, and McCormicks), it became the city's first predominantly black school by 1920. Alumni include Nat "King" Cole, Dinah Washington, and businessman George E. Johnson, and some of its early-20th-century basketball players later formed a fairly successful team called the Harlem Globetrotters.

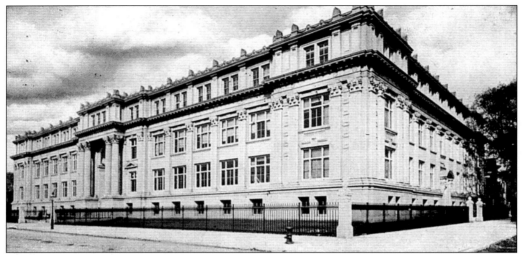

McKinley High School. This building was built in 1903 on the West Side by William Bryce Mundie, who also designed the Beaux-Arts Phillips High School at approximately the same time. One of McKinley's early students was a boy named Walt Disney, who is believed to have published his first cartoons in the school's magazine. The building currently houses the Creiger Multiplex of three schools—an elementary school, a middle school, and a high school—under one roof.

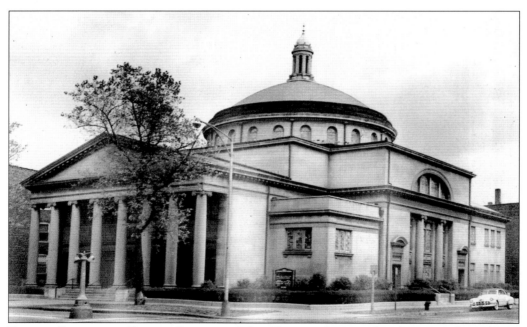

Eighth Church of Christ, Scientist. This Christian Science church, on South Michigan Avenue, was designed by Leon Stanhope in 1910. It is generally built in the same style as the other classical Christian Science churches, including a broad dome and a portico (in this case, Ionic with a simple pediment). Of all the historic Christian Science churches in Chicago, the Eighth is the only city landmark—it was so honored in 1993—and the building is still used by the church. (Courtesy Church of Christ, Scientist.)

No. 4720 South MLK Drive and Chicago's Boulevards. The idea behind Chicago's vast boulevard system dates back to 1849, when developer John Wright envisioned a network of parks connected by boulevards. The longest boulevard, at four and a half miles, is Martin Luther King Jr. Drive (formerly Grand Boulevard), which attracted the most luxurious residential development in the late 19th century, such as this former mansion, whose entrance and ornamentation show classical architecture's potential for richness and decoration.

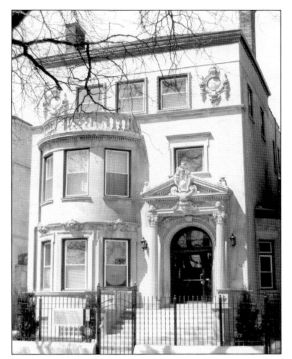

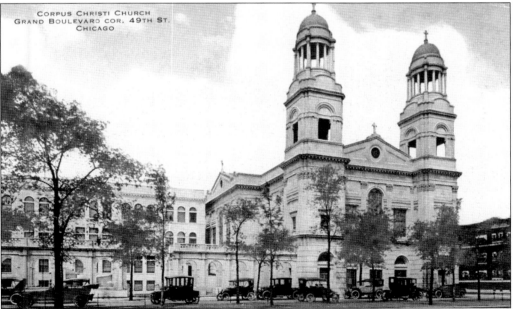

Corpus Christi Church. The church is on the 4900 block of South Martin Luther King Jr. Drive and was built by Joseph McCarthy in 1916. The Renaissance Revival church was McCarthy's first major commission, and he later designed nearly 30 other churches in the next two decades. The church's original members were Irish Catholics. The upper half of both spires have been removed, reportedly because the cost of repairs to the copper-domed steeples would have been prohibitive. (Courtesy Michael and Kate Corcoran.)

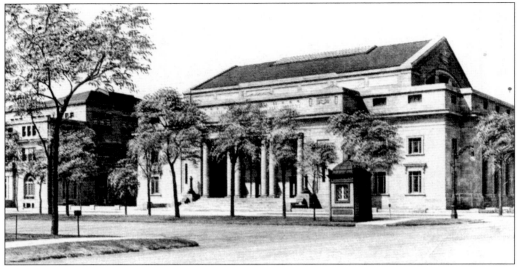

SINAI TEMPLE. In 1912, Alfred Alschuler (better known for his London Guarantee building) designed this Italian Renaissance temple for Chicago's first Jewish Reform synagogue, which dates from 1861. The temple's spatial composition is based on that of ancient Roman baths. The building is now the home of the Mount Pisgah Missionary Baptist Church. (Courtesy Bill Host.)

KENWOOD DISTRICT. Kenwood was originally a wealthy suburb ("the Lake Forest of the South Side") but was annexed by Chicago in 1889. Top architects such as Marshall, Shaw, and Wright designed homes for early Kenwood residents. The district is bounded by East Forty-seventh and Fifty-first Streets and South Blackstone and South Drexel Avenue. This palazzo home, on Ellis Avenue, has a pair of Palladian windows on the second floor and was built in 1897 by Flanders and Zimmerman for meatpacking magnate Gustavus Swift.

FIFTH CHURCH OF CHRIST, SCIENTIST. Originally a Christian Science church and more recently Shiloh Missionary Baptist, the landmark Solon Beman building has been bought by Art Smith, Oprah Winfrey's chef, who plans to convert it into Sanctuary, an arts-based community center. The 1904 building was previously headed for demolition. During the civil rights movement, Martin Luther King Jr., Mahalia Jackson, and many others appeared and performed at the church.

KAM SYNAGOGUE. Now the headquarters of Operation PUSH, the building was originally the home of the oldest Jewish congregation in Chicago (Kehilath Anshe Ma'ariv) after it moved from its previous synagogue at Thirty-third Street and Indiana Avenue. Designed in 1923 by Newhouse and Bernham, the Greek Revival building was purchased by Operation PUSH in 1971, when KAM merged with another congregation.

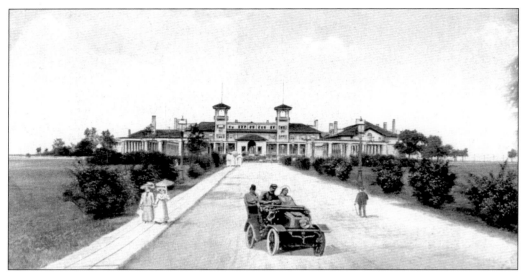

SOUTH SHORE COUNTRY CLUB. Designed in 1906 by Marshall and Fox, the facility was built for Chicago's elite. The original clubhouse, shown here, was built in a Mediterranean classical style that was popular in warm climates but rare in Chicago. The clubhouse (replaced in 1916) was lined with pergolas and colonnades, and inside, first-floor public spaces were decorated with arched windows, gold-topped columns, vaulted ceilings, and detailed carvings. The complex is currently the South Shore Cultural Center. (Courtesy Michael and Kate Corcoran.)

THIRTEENTH CHURCH OF CHRIST, SCIENTIST. This Greek Revival building was built in 1916 and was one of many classical Christian Science churches throughout Chicago. Located in Beverly on the 10300 block of South Longwood Drive, the church was converted into apartments in 1992.

THE WINDERMERE HOUSE. Originally known as the Windermere East, the building was designed in the early 1920s by George and C. W. Rapp. The original Windermere Hotel, to the west of the current building, was built for the fair but has been demolished. In the 1980s, the existing hotel, with its grand entryway, was converted into apartments. The building was once known to be the home of more Nobel Prize winners (from the University of Chicago) than any other building in the world.

JACKSON PARK HIGHLANDS DISTRICT. Like Kenwood, the Jackson Park Highlands District was built with a number of architecturally significant homes. The district was planned in 1905 and includes the 6700 to 7100 blocks of Bennett, Constance, Creiger, and Euclid Avenues and the 1800 to 2000 blocks of West Sixty-eighth through Seventieth Streets. This home, with a two-story temple front, is at 6931 South Euclid Avenue, and the district became a Chicago landmark in 1989.

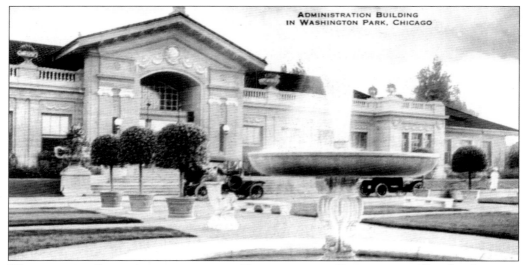

WASHINGTON PARK ADMINISTRATION BUILDING AND BOATHOUSE. The development of Washington Park dates back to 1869, although it was originally known as South Park and included what is now Jackson Park and the Midway Plaisance, a site of the 1893 fair. Frederick Law Olmsted, who was later the fair's landscape architect and also designed Manhattan's Central Park, was hired to design South Park. In the late 19th century, Washington Park became one of the city's most popular parks, particularly among wealthy Chicagoans, and it included man-made lakes, a music pavilion, a botanical garden, croquet courts, an archery range, and even grazing sheep that kept the grass short. The park's Beaux-Arts Administration Building was added in 1910 and designed by D. H. Burnham and Company in a more informal manner that is characteristic of park and garden structures. Since 1971, the building has been the home of the DuSable Museum of African-American History, the oldest museum of its type in the country and named for Jean Baptiste Pointe DuSable, a Haitian fur trader who was Chicago's first permanent settler. The boathouse, which no longer exists, was built on a lagoon in 1902 and consisted of a main structure flanked by two boat shelters, all in the same Ionic style.

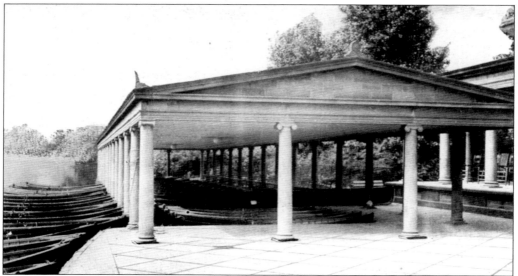

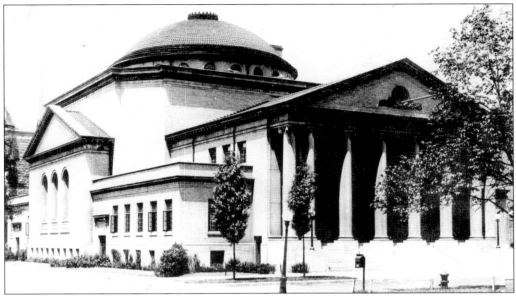

NINTH CHURCH OF CHRIST, SCIENTIST. Although designed by Milwaukee architect Carl Barkhausen, this church is a variation of Beman's First Church of Christ, Scientist, with its classical front and broad dome. The building, which is in Woodlawn, was built in 1916 and is now the home of the St. John Baptist Temple. (Courtesy Chicago Public Library, Special Collections and Preservation Division.)

HIRAM KELLY BRANCH LIBRARY. The Kelly Library opened in 1911 in the Englewood neighborhood on the South Side, at 6151 South Normal Boulevard. Its classical design presents a symmetrical plan centered on the main entrance marked by colossal Ionic columns that span both floors of the building. (The colossal order spans more than one floor.) The columns are embraced by piers which are mimicked in the pilasters that separate large windows. (Courtesy Chicago Public Library, Special Collections and Preservation Division.)

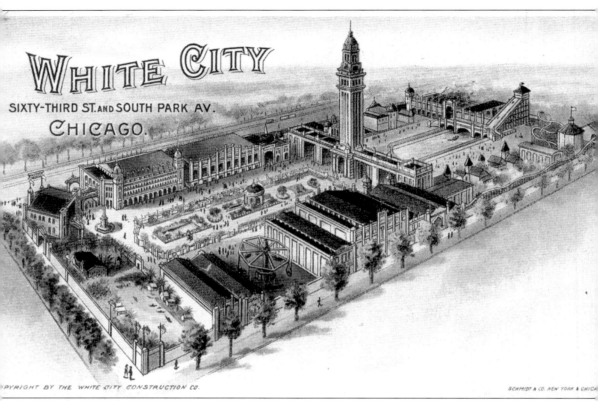

WHITE CITY
SIXTY-THIRD ST. AND SOUTH PARK AV.
CHICAGO.

COPYRIGHT BY THE WHITE CITY CONSTRUCTION CO.

SCHMIDT & CO. NEW YORK & CHICA

WHITE CITY AMUSEMENT PARK. Located at Sixty-third Street and South Park Avenue (now Martin Luther Jr. King Drive) in Woodlawn, the White City was "dedicated to merriment and mirth" and of course inspired by the 1893 fair. According to a 1905 *Chicago Daily Journal* article, printed during the park's first season, "the lights, the broad walks, the water, the electric tower, everything brings recollections of the World's Columbian Exposition, as the builders planned." The park featured several roller coasters and other rides, ballrooms, and other attractions, including a reproduction of Venice's canals and buildings. In addition to its architecture, the White City also replicated the ideals of the 1893 fair and the City Beautiful movement with its wide boardwalks, gardens, and public spaces and its emphasis on order, cleanliness, and beauty as an escape from the difficulties of daily life in the real city of early-20th-century America. Due to a fire and the Depression, most of the park was closed by 1934, although it did not fully shut down until the 1950s.

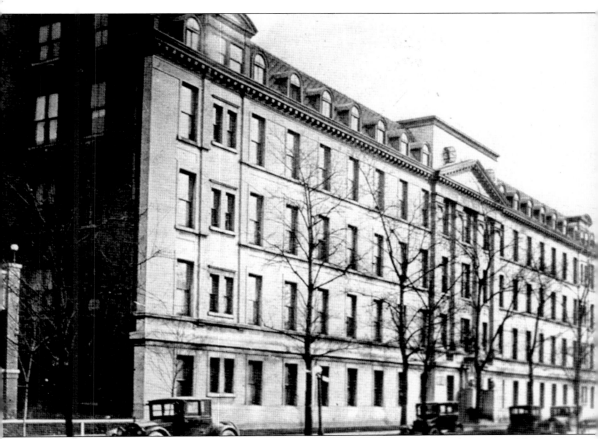

ST. BERNARD HOSPITAL. In 1889, the city of Chicago annexed southern neighbor Englewood—possibly in order to boost its population to second place in the 1890 national census and therefore increase the likelihood of hosting the 1893 fair. At the time, Englewood was second only to the Loop as a center of commerce in Chicago, and the leader of Englewood's St. Bernard's Church saw a need for improved heath facilities in the neighborhood. In 1903, seven Canadian nuns from the Religious Hospitallers of St. Joseph came to Englewood to help build a hospital, and the building was dedicated as St. Bernard Hotel Dieu (French for "House of God") in late 1905. In the last 100 years, the hospital has been renovated and expanded, and the original classical entrance of the main building has been closed to make way for new construction. Today, the George Beaudry–designed building is the only hospital in Englewood, which has been designated as a federal health professional shortage area. (Courtesy Chicago Public Library, Special Collections and Preservation Division.)

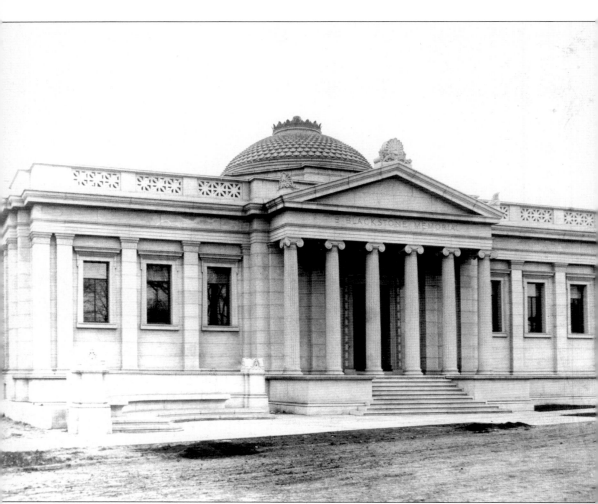

Timothy B. Blackstone Memorial Branch Library. The library, on the 4900 block of South Lake Park Avenue, was the first branch of the Chicago Public Library and opened in 1904. It was funded in honor of the former president of the Chicago and Alton Railroad and founder of the Union Stock Yards by his widow. As with many other classically inspired buildings, its composition is neoclassical, but its details are based on those of the Erechtheion, an Ionic temple at the Acropolis in Athens. Its rotunda contains murals painted by Oliver Dennett Grover, whose works also appeared at the Columbian Exposition. The library was designed by Solon Beman, who is best known for his Christian Science church designs. Beman and other architects applied the ideals of the fair to shape the look of 20th-century Chicago, particularly with the classical design of public buildings, such as government offices, schools, museums, churches and synagogues, and libraries that were built throughout the city in the early 1900s. The designers used classical architecture to convey the importance of these civic buildings. (Courtesy Chicago Public Library, Special Collections and Preservation Division.)